D1431987

EASTER TRADITIONS IN BOSTON

ANTHONY M. SAMMARCO

AMERICA
THROUGH TIME®
ADDING COLOR TO AMERICAN HISTORY

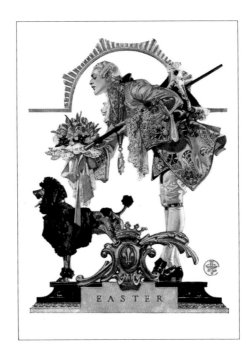

This book is affectionately dedicated to Lilian M.C. Cramer Randall

America Through Time is an imprint of Fonthill Media LLC
www.through-time.com
office@through-time.com

Published by Arcadia Publishing by arrangement with Fonthill Media LLC
For all general information, please contact Arcadia Publishing:
Telephone: 843-853-2070
Fax: 843-853-0044
E-mail: sales@arcadiapublishing.com
For customer service and orders:
Toll-Free 1-888-313-2665

www.arcadiapublishing.com

First published 2021

Copyright © Anthony M. Sammarco 2021

ISBN 978-1-68473-011-7

Typeset in Mrs Eaves XL Serif Narrow
Printed and bound in England

CONTENTS

Opposite page: Fop, Dog, and Flowers, by Joseph Christian Leyendecker for the Easter cover of the Saturday Evening Post, April 19, 1930

Acknowledgments

Joel Andreasen; Boston Public Library, David Leonard; Chuck Bruen; Reverend Robert E. Casey; Ann Gonsalves Cathcart; Hutchinson and Pasqualina Cedmarco; Cesidio "Joe" Cedrone; Edie Clifford; Colortek, Jackie Anderson; Marion Fennell Connolly; The Cotting School, David Manzo, president; Donna O'Neill Craig; the late Rupert A. M. Davis; Jean Degnon; eBay; Mary Ann English; Barbara Smith Fitzgerald; Jane Gonsalves; Maureen Houghton Foster; Edward Gordon; Helen Hannon; Denise Tape Heffron; Karen Hilliard; the Houghton Family; Italian Home for Children, Daniel Brennan; Martin and Deborah Blackman Jacobs; George Kalchev, Fonthill Media; Rozie Keech-Buccella; Peter B. Kingman; Kiki Kneeland; Lauren Leja; Louise Goodnow Lamere; Richard Hunter Lamere; Kena Longabaugh; the late Celia and Joe Magliaro; Maine State Library, Sarah Stanton; the late Martin Manning; Edward Maroney and Reverend Ellen Chahey; Mary Ann Sammartino Nagle; Frank Norton; Timothy O'Connor; Fran O'Hara; Kelli O'Hara; the O'Neil Family; Julia O'Neil; Orleans Camera; Eileen Houghton Phillips; Phillips Chocolates, Joseph Sammartino, Matt Strazzula, Matthew Sammartino and Michael Pocrass; Ron Scully; The Society of St. Margaret, Adele Marie Ryan, SSM, Superior; Alan Sutton, Fonthill Media; James and Patricia Webber Tape; Sheila Houghton Tracy; Ken Turino and Chris Matthias; Archives and Special Collections, University of Massachusetts, Sammarco Collection; the late Dorothy Coleman Wallace; Winston Flowers, David and Ted Winston; Cathryn Wright.

INTRODUCTION

He is not here: for He is risen, as he said. Come, see the place where the Lord lay.

But on the first day of the week, at early dawn, they went to the tomb, taking the spices they had prepared. And they found the stone rolled away from the tomb, but when they went in they did not find the body of the Lord Jesus. While they were perplexed about this, behold, two men stood by them in dazzling apparel. And as they were frightened and bowed their faces to the ground, the men said to them, "Why do you seek the living among the dead? He is not here, but has risen. Remember how he told you, while he was still in Galilee, that the Son of Man must be delivered into the hands of sinful men and be crucified and on the third day rise." And they remembered his words, and returning from the tomb they told all these things to the eleven and to all the rest.

Luke 1-9

Noah Webster describes Easter as "an annual Christian festival in the spring, celebrating the resurrection of Jesus." Though a solemn religious holiday preceded by forty days of Lent and a solemn Holy Week, it would evolve into a day that is celebrated not just with religious services but also with Easter bunnies and Easter baskets.

In most countries in Europe, the name for Easter was derived from the Jewish festival of Passover, and the two religious days were to become intertwined over the centuries. Throughout Europe, Easter was to be known by various names, so in Greek the holiday is called Pascha, in Russian it is Paskhal'nyy, in Italian it is Pasqua, in Spanish it is Pascua, in Danish it is Paaske, and in French it is Paques, all of which derive from the Jewish Passover, which is the most important Jewish seasonal festival. The Council of Nicaea in AD 325 decreed that Easter should be observed on the first Sunday following the first full moon after the spring equinox. However, by the medieval period, the celebration of "Easter" was derived from a pre-Christian goddess in England known as Eostre, who was celebrated at the beginning of spring. Early Christians chose to celebrate the resurrection of Jesus on the same date as the Jewish Passover, which usually fell around the 14th day of the month of Nisan, which was in March or April. These Christians were popularly known as the Quartodecimans, which means the fourteeners. By the seventeenth century, a German tradition evolved of an Easter hare

bringing eggs to good children as hares and rabbits had a long been association with spring seasonal rituals because of their amazing powers of fertility. In fact, decorated eggs had long been part of the Easter festival, and given the obvious symbolism of new life were representative of the resurrection. A vast amount of folklore surrounds the Easter egg and in a number of Eastern European countries, the process of decorating the eggs is extremely elaborate and colorful. Several Eastern European legends describe eggs being dyed red, which was a favorite color for Easter eggs in connection with the events surrounding Jesus' death and resurrection.

However, in early America, the Easter festival was to become far more popular among Roman Catholics than Protestants. In fact, the Puritans in Boston had regarded both Easter and Christmas as far too tainted by non-Christian influences to be appropriate to celebrate, as these festivals also tended to be opportunities for feasting, heavy drinking and merrymaking. Governor John Winthrop famously wrote in his journal that the Arbella departed England for the New World on Easter Monday March 29, 1630. However, the mere mention of Easter would soon disappear from his records and it would become totally ignored by the Puritans settling Massachusetts Bay Colony. The Puritans went to great extremes to abolish all references to pagan gods and popeish rituals of the Roman Catholic and Anglican churches. The Bible, they declared, did not mention holidays so they felt that these feast days were nothing more than Roman inventions. The Puritans said that "They for whom all days are holy can have no holiday." Samuel Sewall, a noted judge and Puritan diarist, once wrote in his journal that he had been given an almanac and he crossed out all the papist holidays in the new book. He said "I blotted against Feb. 14, Valentine, March 25, Annunciation of the B. Virgin; April 24, Easter; Sept. 29, Michaelmas; Dec. 25 Christmas; and no more." Though the Puritans did not like Easter any more than they liked Christmas, they would take the unprecedented step to legally ban Christmas in 1659, fining anyone five shillings for celebrating the holiday. Easter, however, was totally ignored.

The Puritans were not the only people living in Massachusetts Bay Colony. By the late seventeenth century, Anglicans, Huguenots, and Roman Catholics, for example, had also immigrated to the New World. When King James II took the English throne, he consolidated the northeastern colonies. In 1686, he appointed Sir Edmund Andros as governor of the Dominion of New England, who would restore the popeish holidays, celebrating royal holidays and he even allowed a Maypole, no less, to be set up in Charlestown, which caused comment as it was interpreted as a phallic symbol because of pagan fertility rites. Puritan Minister Increase Mather, president of Harvard College, was incensed by these bold actions and he wrote that the devil had "begun his march of triumph." Initially, the Puritans had forced Anglicans to hold services on the Boston Common but Andros wrangled with the Puritan theocracy, and he insisted on holding Anglican services at the Old South Meeting House. On Good Friday in 1687, he ordered the sexton to open the doors of Old South and ring the bell for the call to worship for "those of the Church of England." As the Puritans could not and would not forgive that

particular affront and the desecration by popeish rituals of candles, incense and singing in their place of worship, they revolted in 1689 and sent Andros back to England.

By the nineteenth century, Boston was gradually changing both topographically and also through immigration. By the 1860s, the city had numerous immigrants, which represented almost half the city's population, who began to assimilate and bring their customs and beliefs to the New World and Easter evolved as an occasion to be spent with one's family, which was done partly out of a desire to make the celebration of these holidays less rowdy. Easter Sunday traditions in New England have long included dying eggs, the wearing new clothes, baking hot cross buns and attending sunrise and church services. The story of the Easter Bunny is thought to have become common in the nineteenth century, as rabbits usually give birth to a big litter of babies, called kittens, so they became a symbol of new life. Legend has it that the Easter Bunny lays, decorates, and hides eggs as they are also a symbol of new life. Others brought traditions from Europe and Germans believed, for example, that rabbits laid beautifully colored eggs on Easter. All the while, the chocolate bunnies and eggs serve as a reminder of Easter's ancient origins and Christian traditions.

During the nineteenth century, rabbits increasingly became a popular symbol of Easter with the growth of the greeting card industry, led by the Louis Prang Company in Roxbury, Massachusetts. Prang, an immigrant from Germany, had introduced the first Christmas cards in the United States, and Easter and other holiday cards soon followed. Artistic and beautifully decorated by upwards of 100 employees, Prang cards were said to have "had an individual charm, not merely in design but in technique, lettering, the stock used, and their almost perfect coloring." Following his example, other Easter card designers and producers would include the H.I. Robbins Company, Rust Craft, Norcross, and Hallmark Greeting Cards. With artists such as Tasha Tudor, Joseph Christian Leyendecker, Norman Rockwell, and Ellen Clappsaddle each using their artistic skills to design Easter cards that were either religious, or secular with Easter bunnies, eggs, and flowers, the public was enthralled. It was said that "Card companies like Hallmark became big by launching images of cute little rabbits and Easter eggs on cards" and as postage services became more affordable, people wanted to keep in touch with family and friends.

In the Victorian era, John and Benjamin Cadbury produced the first chocolate candy bar in 1847 and in 1875 their first chocolate Easter egg, after developing a pure cocoa butter that could be molded into smooth shapes, with eventually nineteen different egg designs. The first edible Easter bunnies were actually made from sugared pastry in Germany in the nineteenth century. Chocolate, which had long been enjoyed as either a sweet or savory drink, now became an edible treat for children, and Easter eggs and candy were one of the major areas for the marketing of chocolate. In Boston, numerous chocolate manufacturers produced wonderful Easter confections that included Schrafft's, Fanny Farmer, Whitman Chocolates, Hilliard's Chocolates, and Phillips Chocolates making not just Easter eggs, but a variety of delicious candies that could fill one's Easter basket.

In *Easter Traditions in Boston*, one revisits the long-held traditions of decorating Easter eggs, decorating an Egg Tree, choosing an Easter bonnet, children's Easter egg hunts, attending Easter Services in churches or Sunrise Services before joining the O'Neils and the Houghtons who annually participated in matching Easter outfits in the Easter Parade on the Commonwealth Avenue Mall in Boston's Back Bay. Bostonians have a shared tradition of this very special holiday, and though it was ignored by the Puritans, we can fondly remember in this book how our parents and grandparents celebrated the resurrection of Jesus Christ.

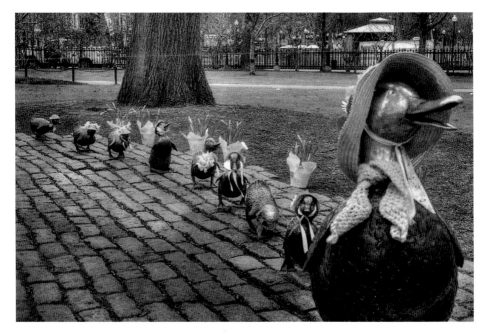

The bronze ducklings in the Public Garden in Boston was sculpted by Nancy Schön as a recreation of the mallard family in Robert McCloskey's children's classic *Make Way for Ducklings*. Seen here, the ducklings, Jack, Kack, Lack, Mack, Nack, Ouack, Pack, and Quack, led by Mrs. Mallard, who lived on an island in the lagoon in the Boston Public Garden, are on their way to visit Policeman Michael who feeds them peanuts daily. The bronze ducklings wear Easter bonnets as they delight children and adults alike on Easter Sunday morning in 2015.

1

ECCE HOMO

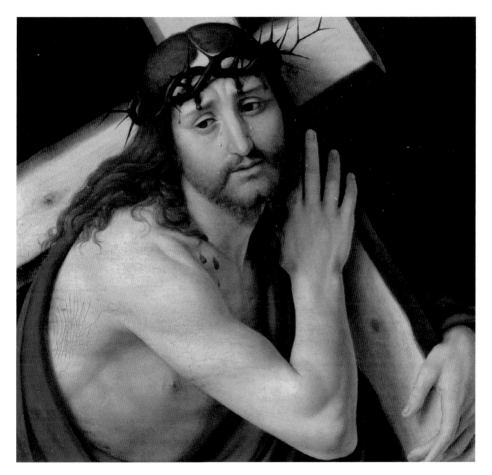

Christ Carrying the Cross was painted in 1505 by Andrea Solario (1460–1524), an Italian Renaissance painter of the Milanese school who was considered one of the most important followers of Leonardo da Vinci. He depicted Jesus Christ carrying the cross with a crown of thorns to his crucifixion, but the emotional aspect of this powerful image is given added force by the introduction of the new dramatic language of expression and gesture with the anguish on the tear stained face of Jesus Christ. (*Collection The Galleria Borghese Museum*)

Whoever does not bear his own cross and come after me cannot be my disciple. Luke 14:27

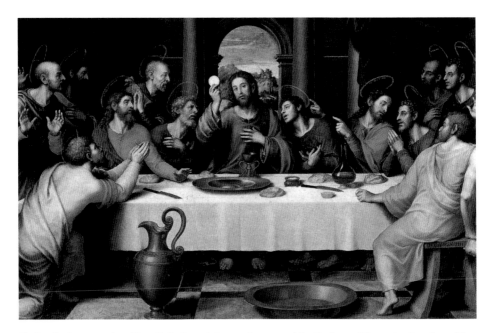

The Last Supper was painted in 1560 by Juan de Juanes (1523–1579) for the base of the main altarpiece of San Esteban in Valencia. In the front right, the traitor Judas is depicted with a money pouch and he is dressed in yellow, the color of envy. He is also the only figure of the twelve disciples without a halo. Jesus is seen consecrating the Sacred Host and the chalice in the center of the table reproduces the one kept in Valencia Cathedral, long considered to be the one used by Christ at the Last Supper. (*Collection Museo De Prado*)

When evening came, Jesus was reclining at the table with the Twelve. And while they were eating, he said, "Truly I tell you, one of you will betray me." They were very sad and began to say to him one after the other, "Surely you don't mean me, Lord?" Jesus replied, "The one who has dipped his hand into the bowl with me will betray me." Matthew 26:20-23

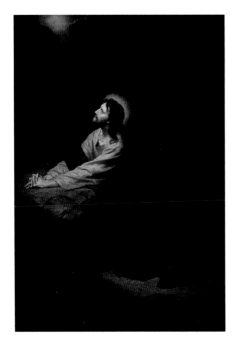

Christ in Gethsemane was painted in 1890 by Heinrich Hofmann, a German painter who is best known for his many paintings depicting the life of Jesus Christ. In this painting, the spiritual drama of Gethsemane, a garden at the foot of the Mount of Olives in Jerusalem, is emphasized with spot lighting the transformation of abject agony into a scene of devotion. Heinrich Hofmann was one of the preeminent painters of his time, and it is said that this painting of Jesus Christ in the Garden of Gethsemane is one of the most copied paintings in the world. (*The Riverside Church, New York City*)

Then Jesus came with them to a place called Gethsemane, and said to His disciples, "Sit here while I go over there and pray." And He took with Him Peter and the two sons of Zebedee, and began to be grieved and distressed. Then He said to them, "My soul is deeply grieved, to the point of death; remain here and keep watch with Me." Matthew 37:36-38

Christian Before the High Priest was painted in 1617 by Gerard van Honthorst when Christ was brought before the high priest by Roman soldiers and was questioned about His teachings and false testimony that was called against Him. The artist creates a dramatic scene with a single candle illuminating the faces of Caiaphas, the high priest, and Jesus Christ, showing the skillful use of Carravagesque lighting effects. Van Honthorst was a Dutch painter who was renowned for his depiction of artificially lit scenes, eventually receiving the nickname *Gherardo delle Notti*, or Gerard of the nights. After being questioned, Jesus was led from Caiaphas to Pontius Pilate in the Praetorium. (*Collection National Gallery, London*)

Jesus is asked: *"If thou art the Christ, tell us. But he said unto them, If I tell you, ye will not believe"* Luke 22:67

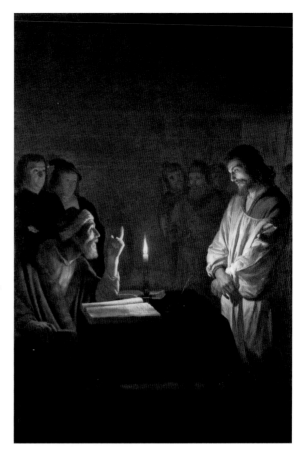

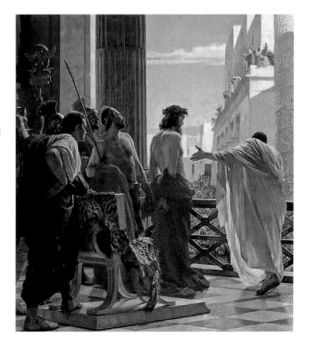

Ecce Homo was painted by Antonio Ciseri in 1871. *Ecce Homo* are the Latin words used by Pontius Pilate, the Roman governor of Judea, in the Vulgate translation of the Gospel of John, when he presents a scourged and mocked Jesus Christ, bound and crowned with thorns, to a hostile crowd from his balcony shortly before His Crucifixion. Ciseri depicts Jesus Christ stripped to the waist as He is presented to the Jews who demanded His crucifixion. (*Collection Museo Cantonale d'Arte*)

Then came Jesus forth, wearing the crown of thorns, and the purple robe. And Pilate saith unto them, Behold the man! John 19:5

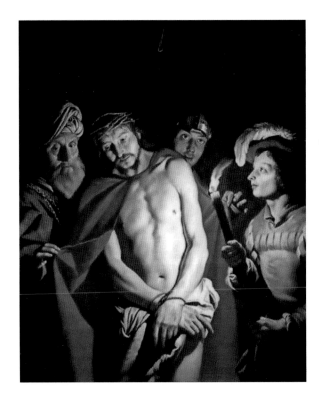

Jesus Christ with Crown of Thorns was painted *c.* 1635 by Matthias Stom, a member of the Caravaggisti. Stom, like his mentor Caravaggio, painted with naturalism and drama high in their pictorial subjects. This masterful painting depicts Jesus Christ in a nighttime scene of torment, illuminated by a single candle held by the man on the right, creating a strong effect of light and dark, good and evil. (*Collection Norton Simon Museum*)

When the chief priests therefore and officers saw him, they cried out, saying, Crucify him, crucify him. Pilate saith unto them, Take ye him, and crucify him: for I find no fault in him. John 19:6

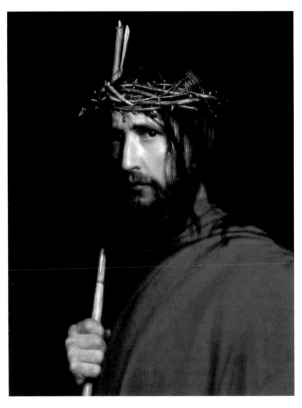

Christ and Thorns was painted in 1888 by Carl Heinrich Bloch (1834–1890). Bloch was born in Copenhagen, Denmark, and studied at the Royal Danish Academy of Art and greatly admired the paintings of Rembrandt Harmenszoon van Rijn, and his distinctive style of painting, which he endeavored to emulate. In this painting, Jesus Christ is depicted in the last hours of His great sacrifice for humanity. His piercing eyes confront us directly, staring into our soul. His perfect meekness and gentleness touch our humanity and empathy.

And twisting together a crown of thorns, they put it on his head and put a reed in his right hand. And kneeling before him, they mocked him, saying, "Hail, King of the Jews!" Matthew 27:29

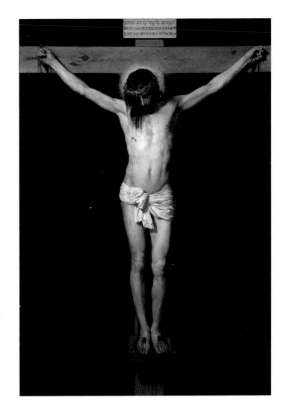

The Christ Crucified was painted in 1632 by Diego Velasquez. In this painting, Velasquez depicts Jesus Christ, with a gentle halo enveloping His lowered head, nailed to the cross with His feet together and supported on a little wooden brace, in a classic contrapposto posture. Both arms draw a subtle curve and the loincloth is painted rather small, thus showing the nude body as much as possible. The spirituality and mystery of this painting is highly evident as we glimpse the last moments before His death. (*Collection Museo De Prado*)

Jesus called out with a loud voice, "Father, into your hands I commit my spirit." When he had said this, he breathed his last. The centurion, seeing what had happened, praised God and said, "Surely this was a righteous man." Luke 23:46-47

The Burial of Christ was painted in 1772 by Francisco de Goya (1746–1828). Following His crucifixion on Golgotha, Joseph of Aramathea asked Pontius Pilate for the body, and after granting his request, he and Nicodemus, the man who earlier had visited Jesus that night and who brought a mixture of myrrh and aloes, took Jesus' body. The two men wrapped it, with the aromatic spices, in strips of linen which was in accordance with Jewish burial customs. The body was then placed in the tomb of Joseph of Arimathea, a disciple who gave Jesus an honorable burial in his own tomb in the garden and because it was the Jewish day of Preparation they laid Jesus there. (*Collection The Lázaro Galdiano Museum*)

Truly, truly, I say to you, unless a grain of wheat falls to the earth and dies, it remains alone; but if it dies, it bears much fruit. John 12:24

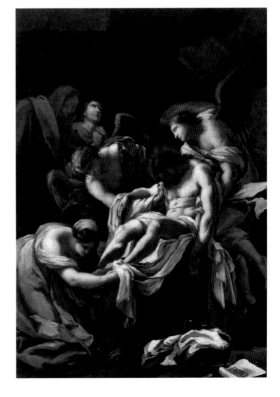

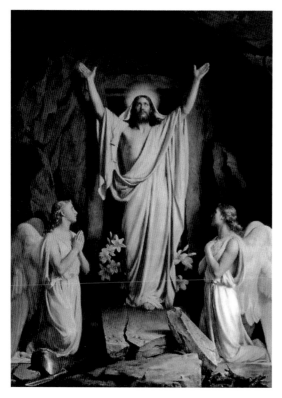

The Resurrection was painted in 1881 by Carl Heinrich Bloch as Jesus emerges from the tomb. Jesus Christ is victorious over death, and emerges from his tomb with adoring angels and white lilies by tomb. In the right foreground a soldier's helmet lies empty on the broken slab. The stigmata and stab wounds are visible in his hands and side and the angels adoringly look to him as he looks to his Father in the Heavens. Triumph, majesty, power, and victory resound in this painting. Bloch has successfully captured a moment of true miracle and holiness. It has been said that Bloch is perhaps the greatest artist ever to interpret the life and death of Christ. (*Collection Brigham Young University Museum of Art*)

Christ the Lord is risen today, Sons of men and angels say. Raise your joys and triumphs high; Sing, ye heavens, and earth reply. Charles Wesley

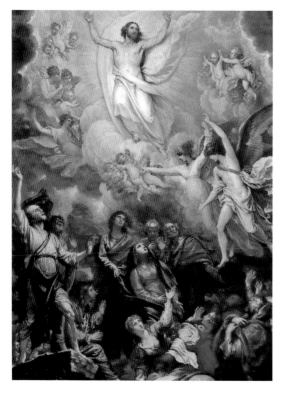

The Ascension was painted in 1801 by Benjamin West (1738–1820) and portrays the glory and magnitude of what Jesus' ascension into heaven means for Christians. The disciples are gathered on the mountaintop looking up in bewilderment and amazement as Jesus Christ ascends to Heaven escorted by angels in all His glory proclaiming to the world that His work on earth is done. Everything has been accomplished and His work of saving mankind from its sin and hell has been completed. (*Collection Denver Art Museum*)

"Why do you stand here looking into the sky? This same Jesus, who has been taken from you into heaven, will come back in the same way you have seen him go into heaven." Acts 1:11

2

EASTER WAS IGNORED IN COLONIAL BOSTON

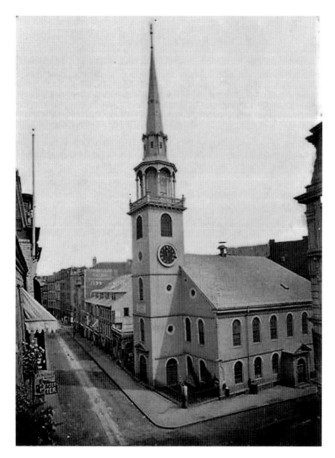

Old South Meeting House in Boston was founded in 1670 as a place of Puritan worship. However it was forced by Royal Governor Sir Edmund Andros (1637–1714), the governor of the Dominion of New England, to open for Anglican worship in Massachusetts Bay Colony and was the first place that Easter was celebrated in Massachusetts. On Good Friday in 1687, Governor Andros ordered the sexton to open the doors of Old South and ring the bell for "those of the Church of England." This caused an affront in Boston and eventually would lead to the founding of King's Chapel in 1686 that was literally, as an Anglican Church, the "King's" own chapel in Boston and a Bible, silver communion service, chancel table, and vestments were given by the monarch.

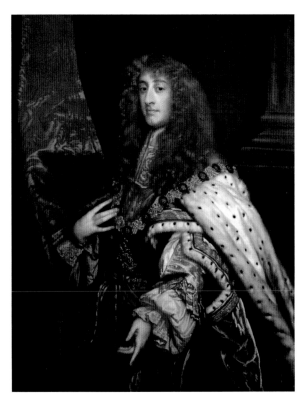

James II and VII (1633–1701) was king of England and Ireland as James II and king of Scotland as James VII. During the Interregnum and his father's exile in France, he had increasingly begun to accept the beliefs and ceremonies of the Roman Catholic Church; he and his wife, Anne Hyde, became drawn to Catholicism. James took Catholic Eucharist in 1669, and although his conversion was kept secret for almost a decade, he tried to influence acceptance of his faith both in England and in the colonies through Edmund Andros. The reluctant acceptance of Easter in Massachusetts Bay Colony was imposed upon the Puritans, and though not legally banned was ignored.

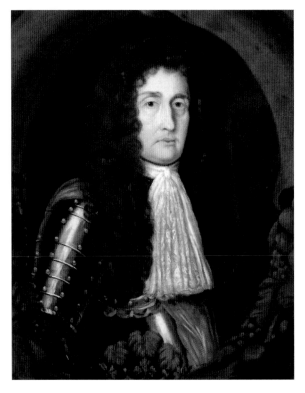

Royal Governor Sir Edmund Andros (1637–1714,) was appointed royal governor of the Dominion of New England in 1686 when the British territories from Delaware Bay to Penobscot Bay were merged under him. Andros enforced the unpopular Navigation Acts, vacated land titles, restricted town meetings, restored the papist holidays, celebrated royal holidays, and allowed a Maypole to be set up in Charlestown, and appropriated a Puritan meeting house for Church of England services and through these actions became one of the most vilified persons in Boston. Considered a bigoted papist, Andros was deposed by a Boston mob in 1689 and the Dominion was voided by William and Mary.

King William III (1650–1702) and Queen Mary II (1662–1694) were joint rulers of England in the late seventeenth century. William of Orange married his cousin, Mary II, the daughter of King James II. The Glorious Revolution of 1689 was to see William and Mary recognized as not just joint monarchs but also forced them to accept parliamentary limitations on their sovereignty over an empire that had begun to broaden not only its size but in its tolerance for other religions and nonconformists. As the Province of Massachusetts was part of their colonies in North America, they ruled through a royal governor, but were the titular heads of the empire.

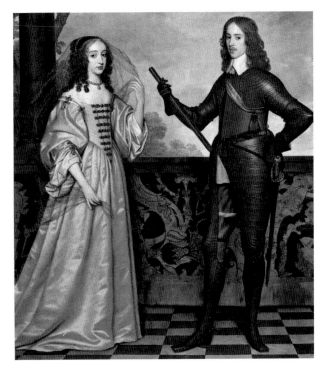

John Winthrop was the first governor of Massachusetts Bay Colony in 1630. John Winthrop famously wrote in his journal that the *Arbella* departed for the New World on Easter Monday, on March 29, 1630. But the Puritan Easter would soon disappear entirely from his records. Upon arriving in Massachusetts Bay Colony, Winthrop and his fellow Puritans took pains to avoid even mentioning the word "Easter," let alone celebrate it. The Puritans wanted to abolish any and all references to pagan gods and papist rituals. The Bible did not mention holidays, they pointed out, so saints' days and feast days were to be considered nothing more than Roman inventions and they dutifully ignored Easter, Whitsunday, and most other holidays.
(*Harvard University Portrait Collection*)

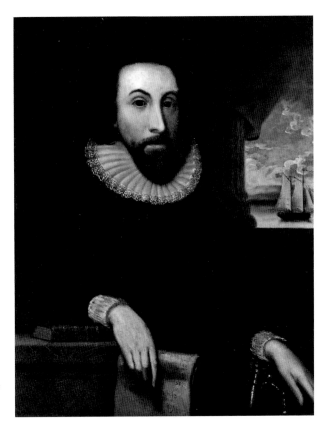

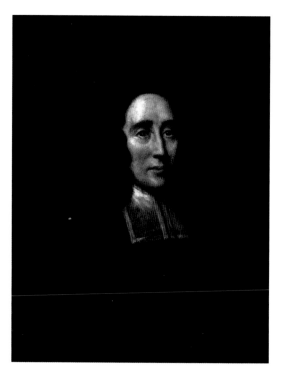

The Reverend Increase Mather (1639–1723) was the son of Reverend Richard Mather, a staunch Puritan minister. Educated at Harvard College, Mather opposed anything openly contradictory to, mutually exclusive with, or potentially distracting from his Puritanical and narrow religious beliefs. When Andros came to Massachusetts and restored the papist holidays and allowed a Maypole to be set up in Charlestown, Mather was appalled. He said that the devil had "begun his march of triumph" in Boston. Mather served as the minister at Second Church in Boston from 1664 to 1723 and was involved with the government of the Massachusetts Bay Colony; he served as president of Harvard College from 1685 to 1702. (*Mansfield College, University of Oxford*)

Samuel Sewall (1652–1730,) a judge in the Province of Massachusetts Bay, was best known for his involvement in the Salem witch trials for which he was one of three judges who sentenced people to death, but would later recant his actions and apologize. In 1681, he was appointed the official printer of the colony and among the first works he published was John Bunyan's *The Pilgrim's Progress*. He served for many years as the chief justice of the Massachusetts Superior Court of Judicature, the province's high court. He was said to have crossed out all the papist holidays in his journals, and he said "I blotted against Feb. 14, Valentine, March 25, Annunciation of the B. Virgin; April 24, Easter; Sept. 29, Michaelmas; Dec. 25 Christmas; and no more." (*Museum of Fine Arts, Boston*)

3

EASTER GREETINGS

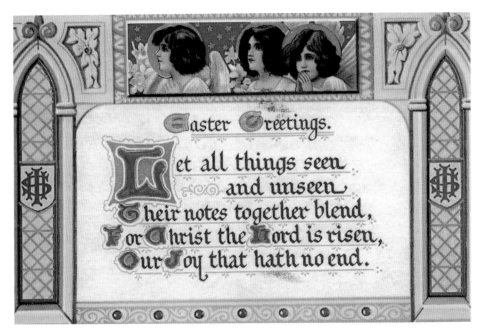

Easter Greetings was a Gothic Revival inspired Easter Card with a trio of angels flanked by lancet leaded glass windows. The card was designed by Nicholas Raymond and printed in 1910 by the A.M. Davis Company of Boston, founded in 1906 by Albert M. Davis, which produced cards of high artistic merit until shortly before World War I. The card's greeting was taken from the writings of John of Damascus in the eighth century and adapted and translated in the nineteenth century by John Mason Neale as the Hymn The Day of Resurrection.

Let all things seen and unseen
Their notes together blend
For Christ the Lord is risen,
Our Joy that hath no end.

Ellacombe

Louis Prang (1824–1909) is considered the Father of the Christmas card as he published in 1874 the first American Christmas card in Boston, though they had been known in England since 1842. A native of Breslau, Prussia, he was to not only produce Christmas, Easter, and other holiday cards in the United States, but it was said during his successful career that "His cards had an individual charm, not merely in design but in technique, lettering, the stock used, and their almost perfect coloring." By the late nineteenth century, his multi-colored chromolithography was considered the foremost art publishing company in the United States.

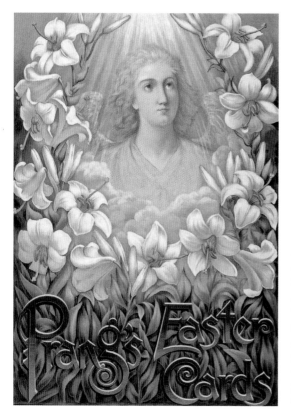

Prang's Easter Cards was beautifully illustrated with an image of Jesus Christ framed by Madonna lilies. This was a large advertising sign for Louis Prang Easter Cards, which would probably be used in a stationery or card store advertising that Prang cards were on sale there. During the late nineteenth century, Prang's greeting cards were sold not just in Boston but in New York, Philadelphia, Chicago, and San Francisco, with regular discounts to the trade.

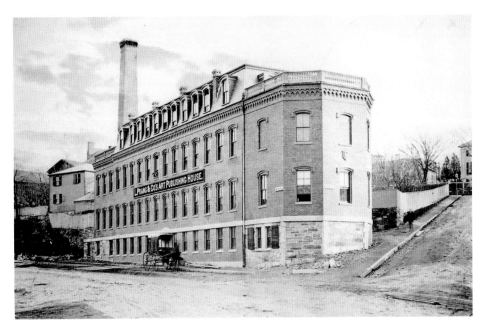

L. Prang & Company Art Publishing House was built in 1872 on Roxbury Street in Roxbury, Massachusetts, behind Prang's home seen on the far left on Centre Street. Prang had begun his career in lithography printing with Julius Mayer as Prang & Meyer in 1856, and in 1860, he bought out his partner and formed L. Prang and Company. The Prang company brought art to the middle class home at a reasonable price and their Easter greeting cards were not just artistic but on the cutting edge of design. In 1897, Prang merged with the Taber Art Company and was known as Taber-Prang Company. Today, his former factory is now a mixed use building, housing residential, and office space.

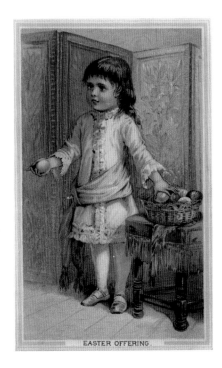

Easter Offering was published by Louis Prang & Company in 1881 with a beautifully dressed child offering a colored Easter egg. Louis Prang traveled to Europe to study printing methods overseas to bring back to Boston. He then realized how he could make a lithograph print look like an oil painting, at a much lower cost. Prang was an active supporter of women artists, both commissioning and collecting artworks by women. Many of his lithographs featured works by female artists such as Fidelia Bridges, Ellen Thayer, Mary Theresa Hart, Rose Mueller, Alice Swan, Rosina Emmet, Dora Wheeler, Olive Whitney, and Lizbeth Humphrey and his company employed more than 100 women.

EASTER OFFERING.

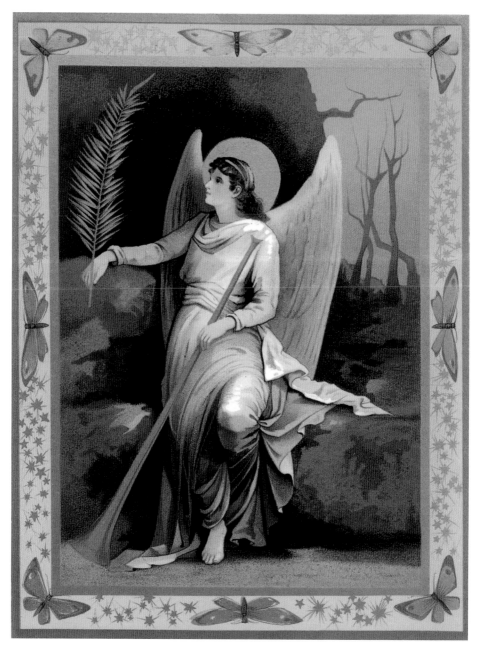

The Angel at the Tomb of Christ, probably one of the more impressive chromolithographs that Louis Prang produced, depicts an angel holding a palm frond and trumpet standing outside the open tomb of Jesus Christ. There were two angels at the tomb of Jesus, as one rolled away the stone they both helped Jesus from the tomb. The palm frond is a symbol of victory, triumph, peace, and eternal life, "He Is Risen!" is on the rock to the right. This card, with a butterfly and star border, was designed and printed in 1883 by Louis Prang. (*Author's collection*)

And, behold, there was a great earthquake: for the angel of the Lord descended from heaven, and came and rolled back the stone from the door, and sat upon it. Matthew 28:2

Fidelia Bridges was one of the many talented artists working at the Prang Factory. She was known for delicately detailed paintings that captured flowers, plants, and birds in their natural settings, and one of the few women to have a successful art career in that period. Her artwork was not simply a copy of what she saw, but with the imagination of a true artist, she infused her subjects with a deep poetic meaning. Frederick Sharaf said that Bridges "combined the temper of romanticism with the technique of a scientist," and she became a specialist in her field and focused on the beauty and serenity of nature. She was a designer at Prang's Factory from 1877 to 1899.

Easter brings the budding spring.

Easter Morning is an Easter card designed in 1866 by Mary Theresa Gorsuch Hart (1829–1921). The card with a white cross draped with flowers and greens was done just after the end of the Civil War and created a solemn aspect to Easter. Hart had studied at the National Academy of Design and was a still life painter in the 1860s for Louis Prang, and by the 1890s, she was accomplished and respected enough as an artist to be asked to write for the *Quarterly Illustrator*, doing illustrations, still life and landscape painting. She was married to James McDougal Hart, a native of Scotland, who was a landscape painter of the Hudson River School.

The Easter Lilly Cross was designed by Olive Elizabeth Springer Whitney (1838–1903) as a flower decorated cross with Madonna Lilies and Lilies of the Valley for Louis Prang. By 1881, L. Prang & Company employed more than 100 women as designers, artists, finishers, and embellishers and Whitney was the resident designer, and well respected for her flower paintings, illustrations, and designs. Her husband was John Webster Perkins Whitney, an engraver.

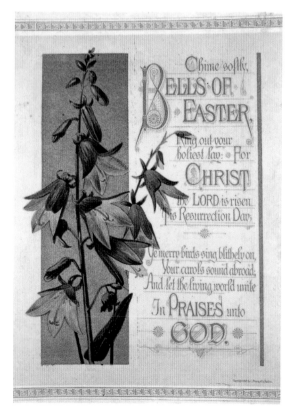

The Bells of Easter was printed by Louis Prang in 1881 with bluebells, a flower long associated with everlasting love and constancy. Bluebells are said to be a favorite with the woodland fairies and were a sure sign that spring has arrived. The Bells of Easter, seen here, was also a Vesper Hymn that was composed by Dimitri S. Bortniansky. Like chimes pealing the good news, this festive hymn announces Resurrection Sunday with style and flair.

The Bells Of Easter Sweetly Peal
"Christ Is Risen! Christ Is Risen!"
They Chime The Hope He Doth Reveal,
This Joyful Easter Day.

Burton Hockey Winslow

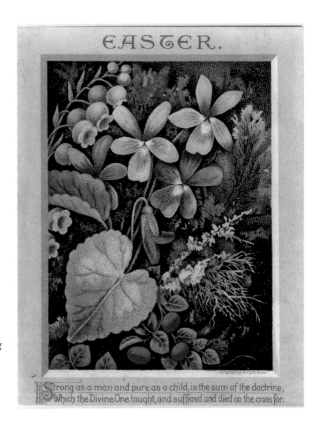

Easter Day is an Easter card with two Calla Lilies with smooth, sword-like foliage framed by a cabochon jeweled border. The meaning of calla lilies is purity, holiness, and faithfulness and the flower is often depicted in images of the Virgin Mary as they are shaped like trumpets, which symbolize triumph. Louis Prang printed this card in 1884 and the Easter greeting was "I send thee pure, bright flowers that say Earth has her Resurrection Day!"

Easter is an Easter card with woodland flowers including lily of the valley, chionodoxa, violets, and snowdrops, all early spring flowers that are the harbingers of Easter. Designed by Nina Moore, Louis Prang printed this card in 1881 and the Easter greeting was "Strong as a man and pure as a child, is the sum of the doctrine, Which the Divine One taught, and suffered and died on the cross for."

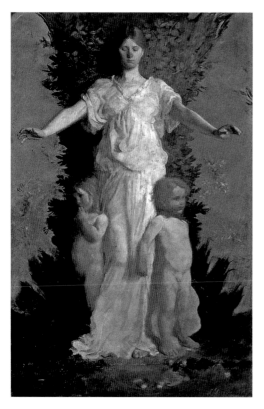

The painting Caritas was by Abbott Handerson Thayer whose art, often inspired by the Italian Renaissance and classical antiquity, fulfilled the aspirations of a country seeking to establish itself on an international stage as the new Rome. With large public buildings in classical styles, with murals, and with allegorical representations like Caritas, American artists created an image of strength and confidence that came to characterize the American Renaissance. The model for Caritas was Elise Pumpelly Cabot, daughter of Raphael Pumpelly, a well-known geologist and the first professor of mining at Harvard. The artist idealized her by dressing her in a flowing Greek chiton, using its long columnar folds to give the impression of stability and strength with her arms outstretched over the two children, so innocent and trustful, seem the embodiment of natural purity.

King of glory, soul of bliss, Alleluia!
Everlasting life is this, Alleluia!
Thee to know, thy power to prove, Alleluia!
Thus to sing, and thus to love, Alleluia!

Charles Wesley

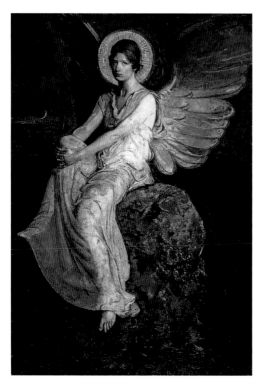

The Guardian Angel was painted in 1903 by Abbott Handerson Thayer, sitting on the rock guarding the tomb of Jesus from which He rose. Thayer is known for his ethereal paintings of angels as well as portraits of society woman and children, landscapes, and delicate flower paintings. *The Guardian Angel* was painted with Bessie Price, a servant in the artist's household, serving as the model and the painting known as the Stevenson Memorial, painted to commemorate the life of the writer Robert Louis Stevenson. Interestingly, Thayer's sister Ellen Bowditch Thayer Fisher worked for Louis Prang from 1884 to 1887 and was a designer who painted well executed flowers that were used on Easter greeting cards.

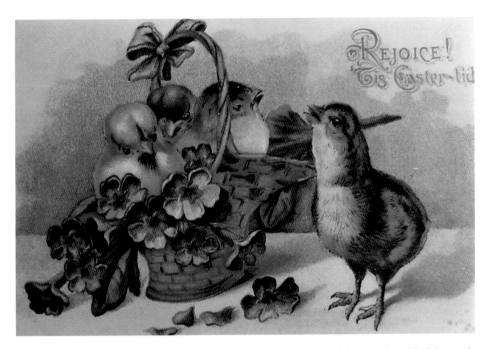

The H.I. Robbins Company was a publisher and printer of New England view-cards and holiday cards in tinted halftone. They distributed many of their cards through the Metropolitan News Company that was located on Bow Street in Everett, Massachusetts. Their cards were printed in Germany from 1907 to 1912 and were distributed throughout the Boston area. Here four chicks in a basket of violets chirp the greeting "Rejoice! Tis Easter-tide."

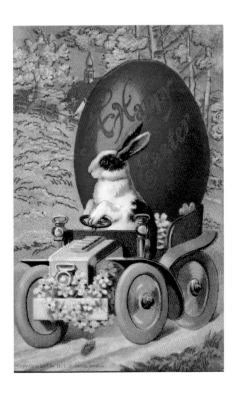

A bunny is depicted driving a car with an enormous red Easter egg in the backseat that says "A Happy Easter," which was printed in 1907 by H.I. Robbins Company. The company was a popular publisher and printer of New England view-cards and holiday cards in tinted halftone. By 1909, the company was known as the Robbins Brothers and their Metropolitan Lithography and Publishing Company, in Everett, has three brothers as officers, Joseph M. Robbins, H. M. Robbins, and H. I. Robbins, with fifteen workers.

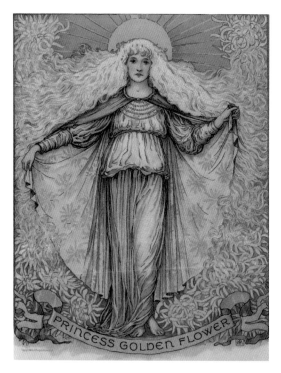

Princess Golden Flower was a glorious chrysanthemum decorated card with brilliant Art Nouveau splendor by F. Schuyler Mathews and printed in 1890 by Louis Prang. It vividly represents the spring equinox in which the amount of dark and the amount of daylight is exactly identical, so one can tell that the earth is emerging from winter because the daylight and the dark have come back into balance. The chiton-dressed princess wearing a diaphanous cape has long golden tresses that morph into chrysanthemum petals as she stands before the rising sun.

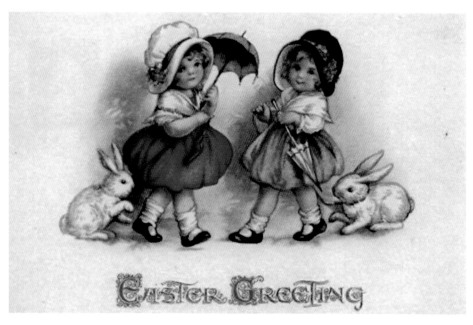

Easter Greetings was a card designed by Ellen H. Clappsaddle (1865–1934), an American artist at the turn of the twentieth century who is recognized as one of the most prolific postcard and greeting card artists of her era. Clapsaddle's greatest success was in the development of her artwork into single-faced cards that could be mailed as postcards. Her artistic designs had become highly prized and she is credited with over 3,000 designs in the postcard field during her career. Here two adorable little girls are accompanied by white bunnies.

Easter Greetings shows a rabbit, bearing a woven wicker basket on its back filled with colored eggs and a pussy willow walking stick arriving for Easter Sunday. During the Middle Ages, people began decorating eggs and eating them as a treat following mass on Easter Sunday after having fasted through forty days of Lent.

Heedless of the wind or rain
Here we come, A merry Train;
Just a chirp A greeting gay
On this happy Easter-day.

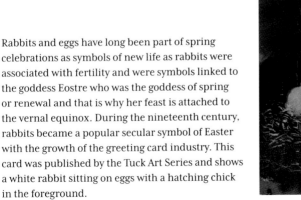

Rabbits and eggs have long been part of spring celebrations as symbols of new life as rabbits were associated with fertility and were symbols linked to the goddess Eostre who was the goddess of spring or renewal and that is why her feast is attached to the vernal equinox. During the nineteenth century, rabbits became a popular secular symbol of Easter with the growth of the greeting card industry. This card was published by the Tuck Art Series and shows a white rabbit sitting on eggs with a hatching chick in the foreground.

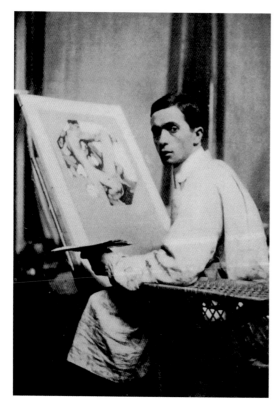

Joseph Christian Leyendecker (1874–1951) was one of the preeminent American illustrators of the early twentieth century, was considered the most in vogue and popular American illustrator of his day. In fact, it was said that the 1920s were in many ways the apex of Leyendecker's career, with some of his most recognizable work being completed during this time. Leyendecker's work on illustrations for various holidays both reflected and helped mold many of the visual aspects of the era's culture in America.

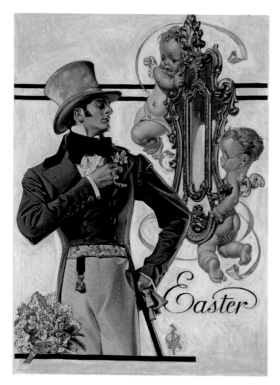

Easter by Joseph Christian Leyendecker was used for the cover of the *Sunday Evening Post* on April 11, 1925. A veritable "Beau Brummel" preens before a gilded mirror held by two putti as he places a flower in his lapel. Off to the Easter Parade! Between 1896 and 1950, Leyendecker painted over 400 magazine covers during the Golden Age of American Illustration, for *The Saturday Evening Post* alone, and he produced over 300 covers, as well as many advertisement illustrations for its interior pages.

The Easter Promenade by Joseph Christian Leyendecker was used for the cover of *The Saturday Evening Post Easter Issue*, March 26, 1932. A bewhiskered gentleman with his top hat, gloves, and cane escorts his beautiful wife in a pink Worth gown covered in frills, but ruffles and especially in flounces to the Easter Parade with doves hovering above and the path lined with Madonna Lilies and tulips. Leyendecker and other illustrators of the day invented the modern magazine cover as a miniature poster that would both engage the viewer and hopefully help to sell the issue, and his detailed art work was known for its eye catching appeal.

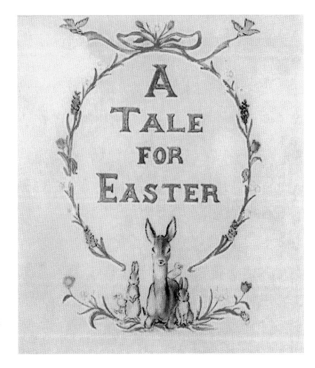

A Tale for Easter was written and illustrated by Tasha Tudor and published in 1941. Tudor said "Springtime is special, and Easter is the most magical day of all!" You can never tell what might happen on Easter. You might find colored eggs waiting in your shoes, or a basket of ducklings at your kitchen table, or a sweet bunny in Grandma's rocking chair. The narrative of this delightfully old-fashioned picture-book describes the coming of Easter, and Tudor declares that if a child has been good, they will have lovely dreams, the night before the holiday.

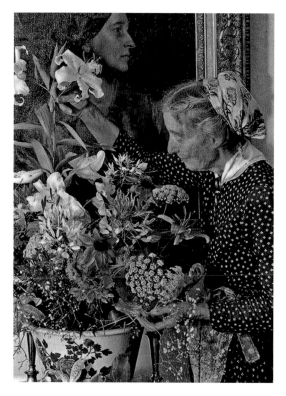

Tasha Tudor (1915–2008) was a fascinating author and artist whose greeting cards evoke an old fashioned quality and the charm of home life. She was known across the country for her glowing watercolor depictions of the New England rural scene of a century ago and for her exquisite paintings of children, flowers, and animals. Born Starling Burgess, she was the daughter of naval architect W. Starling Burgess, known as "The Skipper" and noted portrait painter Rosamond Tudor. A Boston Brahmin, Mrs. Tudor arranges wildflowers before a portrait of her great grandmother Euphemia Fenno Tudor, wife of Frederic Tudor, the Ice King of Boston. She embraced the life of the nineteenth century, dressing in the fashion of the 1830s and she evoked a sense of history in her home and in her artwork.

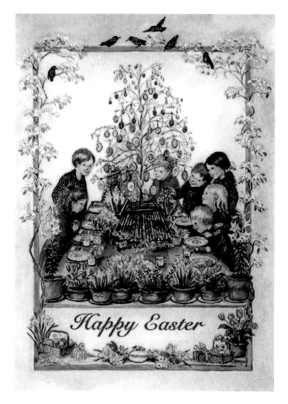

Tasha Tudor illustrated almost 100 books, the last being *Corgiville Christmas*, released in 2003. Seen here from her book *A Time to Keep: The Tasha Tudor Book of Holidays* is a watercolor of a table top Easter tree surrounded by gleeful children. She said "We always had the most wonderful Easter egg tree with goose, duck, chicken, bantam, and pigeon eggs. On the very top were canary eggs." In Sweden, Easter trees are called "Påskris" and are often seen decorated with poultry feathers in addition to hand painted eggs and other ornaments. *The New York Times* said in 1941 that Tudor's pictures "have the same fragile beauty of early spring evenings."

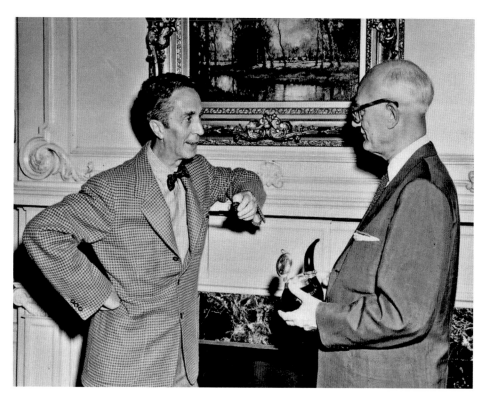

Norman Perceval Rockwell (1894–1978,) seen on the left with Joyce Clyde Hall of Hallmark Cards, was a well-known author, painter, and illustrator and his iconic art works enjoy a broad popular appeal in the United States for its reflection of American culture. Rockwell is most famous for the cover illustrations of everyday life he created for *The Saturday Evening Post* magazine over nearly five decades.

Norman Rockwell was associated with Hallmark Cards in the post-World War II era when he created some of the most charming greeting cards of the period. This iconic painting *Easter Morning* was on the cover of *The Saturday Evening Post* on May 16, 1959, and depicts a father reading the Sunday newspaper as he crouches in his Eames chair as his wife and children in their Easter finery, clutching their Bibles, walk behind him to attend church. The mother depicted in the painting was Rockwell's daughter-in-law, Gail Rockwell, who, when asked to pose, pointed out that she was too young to be the mother of such a family. Rockwell gave the father's tousled hair a pair of unruly "horns" and notice the smug look on his son's face, while the others simply ignore him.

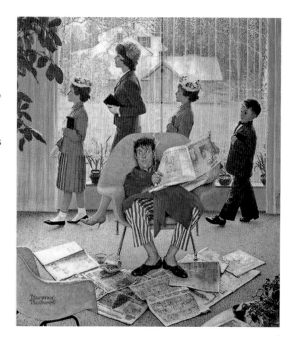

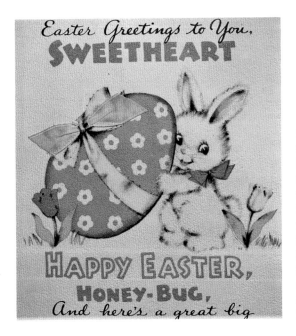

Easter Greetings to You,
SWEETHEART

HAPPY EASTER,
HONEY-BUG,
And here's a great big

Hallmark published this Easter card in 1947, with "Easter Greetings to You Sweetheart." With a larger than life ribbon encircled Easter egg and a smiling Easter bunny, this was sure to please the giver's "Honey-Bug." In 1928, the company introduced the brand name Hallmark cards, after the hallmark symbol used by goldsmiths in London and in 1944 the popular advertising adage "When you care enough to send the very best" was first heard by the public.

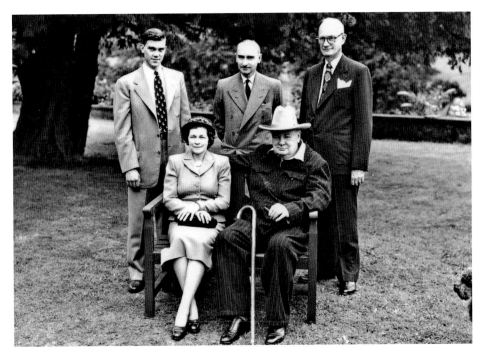

Joyce Clyde Hall (1891–1982), standing on the right, was the founder of Hallmark Cards, and Winston Spencer Churchill was an artist often commissioned to paint scenes for greeting cards in the 1950s. Hall founded his greeting card company in 1910 and so popular were his cards that his staff was increased and they not only produced holiday cards but every day greeting cards. Here in 1950 the Halls were visiting Chartwell, the Churchill country house near Westerham, Kent, in Southeast England. Standing from left to right is Don Hall, Anthony F. Moir, Winston Churchill's solicitor, and Joyce Hall. Elizabeth Hall is seated next to Prime Minister Winston Churchill.

Rust Craft Greeting Card Company was a popular greeting card company that was started by Fred Winslow Rust in 1906 in Kansas City, Missouri. Fred Rust was later to be joined by his brother, Donald Rust, and their cards "always strove to maintain the highest standards in design, reproduction and composition." Rust Craft revolutionized the use of the "French Fold," a method of folding paper into quarters in order to print a card on a single sheet of paper with a single printed side. Many of the "firsts" in the greeting card industry belong to Rust Craft, including anniversary and graduation cards. Fred Rust and his staff wrote many of the most popular messages. First located in Boston's South End, it moved in 1954 to Rustcraft Road in Dedham, Massachusetts. (*Courtesy of the Maine State Library*)

Rust Craft was started by Fred Winslow Rust and this card with a kitten peeking from a Tole painted tea pot was designed by Marjorie Cooper as an Easter Greetings to a Special Friend of Mine! From 1934 to 1958, Marjorie Cooper designed greeting cards for Rust Craft in Boston, Massachusetts, after which she worked for Gibson Cards. Many of the cards published by Rust Craft were sentimental and charmingly old fashioned, and it was interesting that the company also produced greeting cards with messages in Braille.

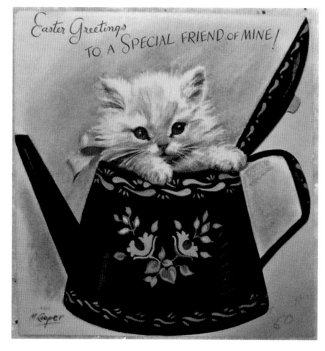

There's gladness in the Easter Day and In my wishes, too;
For there is gladness in my heart With every thought of you.

June Norcross Webster was co-founder in 1924 of the Norcross Greeting Card Company with her brother, Arthur Dickinson Norcross, in New York City. It was said that "From the start Norcross cards had a 'look' which contributed to their selling success although, through the years, the company commanded only a small share of the greeting card market." In 1981, Norcross and the Rust Craft Greeting Card Companies merged to create one large greeting card company.

This Easter card was designed by June Noroross Webster and printed in 1930 with an Art Deco inspired design using a Madonna Lilly. Norcross Company was well known for "beautiful personal greeting cards, many consisting of copper plate etchings, dry point and gravures on hand-made papers, each painstakingly hand colored with envelopes to match." A popular innovation of the Rust Craft Company was a greeting card bearing the sentiment on the card itself with four or five extra sentiments tucked in as part of the message and design and was so popular that it was patented with the name Tukkin.

4

EASTER EGGS

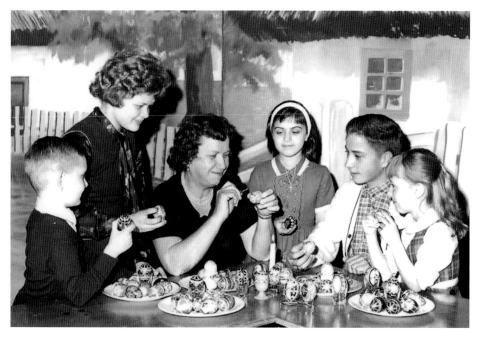

A pysanka is a Ukrainian Easter egg, decorated with traditional Ukrainian folk designs using a wax-resist method. The word pysanka comes from the verb pysaty, which means to inscribe, as the designs are not painted on, but inscribed with beeswax. The woman seated in the center shows the children the technique she uses to decorate Easter eggs, which has been handed down through generations of the Ukrainian people. Traditionally, it was women who decorated eggs, and often men were banned from the room in which eggs were being decorated. In the foreground is a mixture of modern, diasporan, and traditional Ukrainian pysanky, which would surely become treasured heirlooms for families. Among those seen are from the right Samuel Swawka, Annie Hawrylak, Catherine Sawka, Natalie Pronko, Thoedore Sawka, and Julia Sawka.

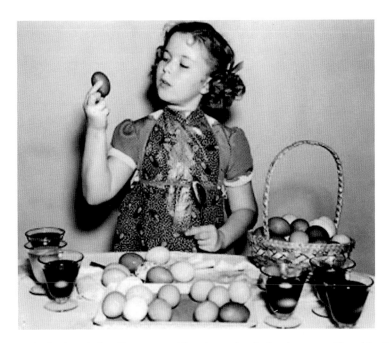

The child star Shirley Temple dyes Easter eggs with various colors in the glasses on either side of the eggs. Temple began her film career at the age of three in 1931 and she achieved international fame in Bright Eyes, and receiving a special Juvenile Academy Award in February 1935 for her outstanding contribution as a juvenile performer in motion pictures. Film hits such as *Curly Top* and *Heidi* appeared during the 1930s along with her "little" pictures such as *The Little Colonel* and *The Littlest Rebel*. However, her signature song, "On the Good Ship Lollipop" was to secure her everlasting fame. So popular an actress was she that her likeness was used for dolls, dishes, and clothing and her decoration of Easter eggs went viral with the public.

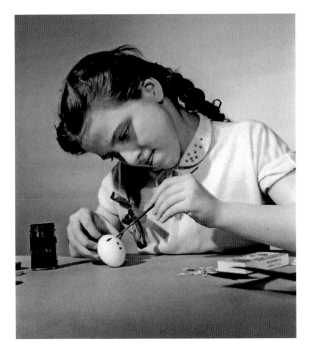

This young girl is carefully painting a design on an egg. Acrylic paint is usually the easiest to work with and creates vibrant colors when it dries. Egg decoration, which draws inspiration from traditional designs or continues to develop new forms, offer a wide variety of techniques to try.

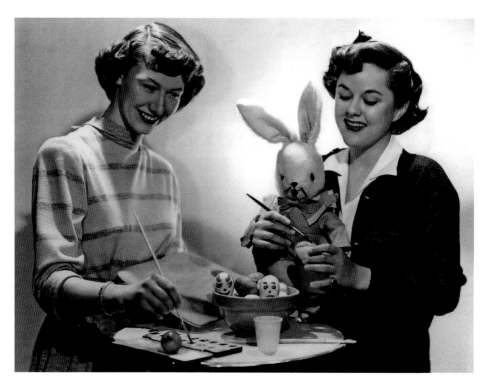

With the help of a stuffed Easter bunny, these two women paint eggs using a watercolor paint box that had a variety of colors. With a tin metal box holding sixteen colors made by Milton Bradley Company, they paint eggs with expression-filled faces. Unlike traditional colored eggs, these whimsical eggs become a unique character of the women's vivid imagination. This type of decorating Easter eggs is so simple and fun that you will laugh at how funny the eggs are decorated just like these two artists are.

Fleck's certified Easter Egg Colors had been known since 1889 when they were offered by J.J. Fleck with pure color ingredients. With a charismatic rabbit strutting on the cover of the box with top hat, morning coat, striped trousers, and cane, it offered popular colors for eggs. By the 1970s, the Fleck Egg Dye Company had grown to be the second largest egg dye company in the United States, but that was not the only product that Jacob Fleck was successful at selling. Fleck originally started as a druggist and eventually specialized in formulating a wide variety of animal stock foods and remedies that were sold all across the United States.

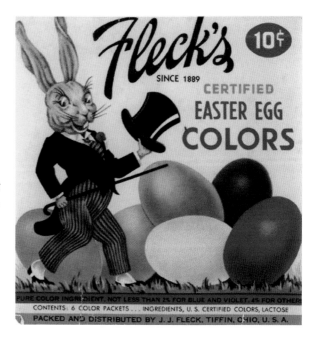

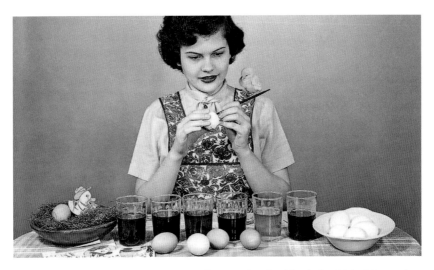

Mary Ellen is seen coloring Easter eggs with a paintbrush with a baby chick sitting on her shoulder, intently watching the procedure. With an apron to protect her clothes from the many glasses of dye in the foreground, she creates colorful eggs that she will place in the straw covered plate on the left for Easter Sunday. The egg is widely used as a symbol of the start of new life, just as new life emerges from an egg when the chick hatches out, so the little chick on her shoulder represents new life just hatched from an egg as well as an adorable chick.

I have a wondrous Easter egg,
All white and shining too;
If I should break it, and I might,
I wonder what I'd do!

Alix Thorne

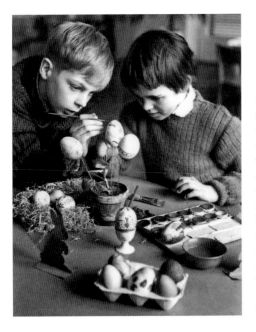

Children often like to paint Easter eggs as it allows their creativity to shine. The 1960s was the decade when Mod Podge, which was invented by Jan Whetstone, changed the way people decorated their Easter eggs. Here the children have blown out the egg and they have the egg shell on a wire secured in a stone dust filled clay pot so they can decorate all sides of the egg with decorations and colors. The unique designs children painted in bright colors that could be sealed with Mod Podge.

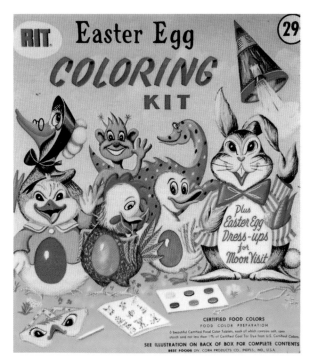

Pier Angeli, whose real name was Anna Maria Pierangeli, was an Italian-born television and film actress. Her American cinematographic debut was in the starring role of the 1951 film *Teresa*, for which she won a Golden Globe Award for Young Star of the Year. Though she was in many films, and was associated with MGM, but when she went to Warner Brothers for the movies *The Silver Chalice* and *Mam'selle Nituche*, she achieved fame. Here she paints Easter eggs that she uses to decorate a wire two tier syllabub stand with cups filled with sweets.

RIT Easter Egg Coloring Kit offered certified food colors so children could color eggs in the 1960s. RIT is a brand of dye first produced in 1918 by Charles Huffman who named his new product RIT in honor of a friend Louis L. Rittenhouse who helped the new company financially and became its first vice president. The trademark, RIT, and the slogan "Never Say 'Dye'... Say RIT!" was registered. It was used for a variety of purposes from dying clothing or coloring shoes, but these coloring kits became immensely popular in the mid-twentieth century. This kit offers Easter Egg dress-ups for a Moon Visit, as the landing by *Apollo 11* crew members Michael Collins, Buzz Aldrin, and Neil Armstrong on the Moon took place in 1969.

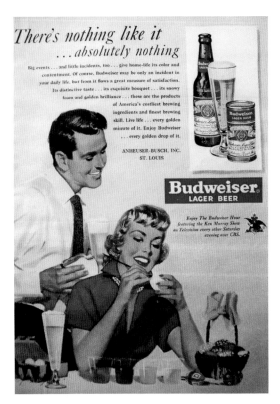

It was said that "There's nothing like it ... absolutely nothing" as sipping Budweiser Lager Beer was certainly one way to relax when coloring Easter eggs. This 1950 advertisement was drawn by Howard Forsberg and showed both mom and dad enjoying a tall cold beer. Introduced in 1876 by Carl Conrad & Co. of St. Louis, Missouri, Budweiser has become one of the largest-selling beers in the United States and "its distinctive taste ... its exquisite bouquet ... its snowy foam of golden brilliance" are sure to be enjoyed, so let us hope mom finishes coloring the eggs before she finishes her beer!

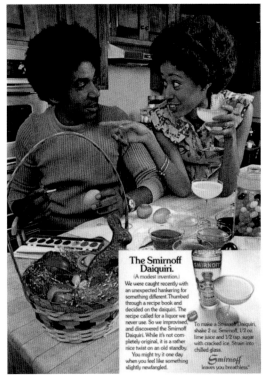

Coloring Easter Eggs can be a time consuming and exacting activity, but seen here in a Smirnoff advertisement from the 1970s, mom and dad are enjoying a Smirnoff Daiquiri, a modest but potent libation, while coloring eggs, which is a rather nice twist on an old standby. The cellophane grass-filled Easter basket in the foreground already has a chocolate Easter bunny and eggs, but with the addition of these multi-colored eggs, it will be an obvious hit on Easter morning so long as a second round of daiquiris is held off until the eggs are colored.

Shake two ounces of Smirnoff, ½ ounce lime juice and ½ teaspoon of sugar with crushed ice. Enjoy!

Dyeing Easter eggs with their PAAS dye kit are (*from left to right*) William Heffron, James McLean, Kathryn McLean, and Charlie Heffron. PAAS Easter Egg Pure Food Color Kit was invented in 1881 by William Townley who owned a drugstore in Newark, New Jersey, where he came up with a recipe for Easter egg dye tablets that tinted eggs five cheerful colors. He renamed his business the PAAS Dye Company, which is derived from "Passen," the word that his Pennsylvania Dutch neighbors used for Easter. (*Courtesy of Denise Tape Heffron*)

An Easter egg hunt is an enjoyable game in which decorated eggs, which may be hard-boiled eggs, chocolate eggs, or even colored plastic eggs containing candies, are hidden for children to find. Egg Rolling is also a traditional Easter egg game played with eggs at Easter. The eggs often vary in size, and may be hidden both indoors and outdoors. When the hunt is over, prizes may be given for the largest number of eggs collected, or for the largest or the smallest egg collected.

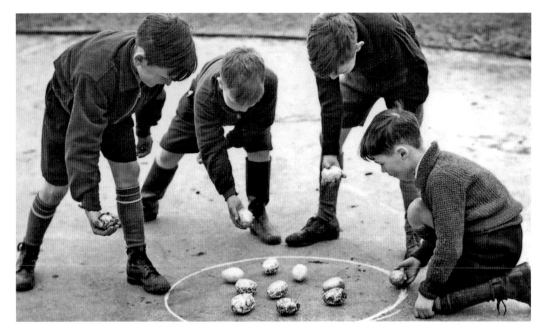

These boys are playing "Tap the Egg," which is a game similar to boccie but using decorated Easter eggs. The player rolls the egg, trying to knock the pointed end of an Easter egg against the broader part of the other player's Easter egg all the while staying within the circle. The one whose egg cracks is knocked out, and the winner is the one who manages to crack as many opponents' eggs as possible. Sometimes the game has a devious side, as the egg could be made harder by being blown out and filled with resin!

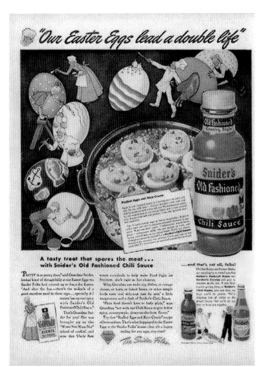

After dyeing eggs for Easter, there were often many left uneaten. Snider's offered a solution to these uneaten eggs by offering a recipe for deviled eggs using their old-fashioned chili sauce. Thomas A. Snider started the T.A. Snider Preserve Company of Cincinnati in 1879, and was renowned for his catsup recipe made from fresh tomatoes without preservatives. Snider was one of the largest ketchup makers at the turn of the twentieth century, and their chili sauce certainly added a zing to foods. It was said that "If the Snider's Folks put it up—it tastes like Home."

12 hard-boiled large eggs
1/4 cup mayonnaise
3 tablespoons Snider's chili sauce
1 teaspoon prepared mustard
1/4 teaspoon hot pepper
Slice eggs in half lengthwise and remove yolks and set whites aside. In a small bowl, mash yolks. Stir in the mayonnaise, chili sauce, mustard and hot pepper sauce and stuff into egg whites. Sprinkle with paprika.

5

The Easter Parade

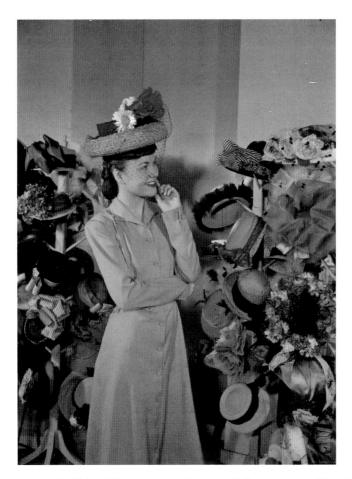

In your Easter bonnet with all the frills upon it, or in this case silk flowers and a veil! An Easter bonnet is said to be any new or fancy hat worn as a Christian head-covering on Easter Sunday, and represents the tradition of wearing new clothes at Easter. This woman certainly has a large selection of hats to choose from, but her raffia straw hat with a black net veil is embellished with silk daises and a rose. As the 1933 Irving Berlin song goes "You'll be the grandest lady in the Easter parade." Anyone can wear an Easter bonnet that can sometimes be traditional, crazy or silly, that expresses their unique personalities.

One only needs to see a smile in a white crape bonnet in order to enter the palace of dreams. Victor Hugo.

Richard Hunter Lamere, aged three, tries on an Easter bonnet in 1959 as his mother, Louise Goodnow Lamere of Milton, Massachusetts, gets advice on her own Easter bonnet from John McLean at his Quincy Square Millinery Store. When women wore hats, they often sought a milliner who could create something that not only attracted attention but made a distinctive statement. Hats were designed, created, and recreated with lace, veils, ribbons, and bows or little veil things that made one feel like a movie star, or straw hats with wide brims, and cloches, close-fitting hats, that echoed a Gibson girl. (*Author's collection*)

The fashion show for millinery was often sponsored by large textile and fashion stores. Easter bonnets were said in *The Illustrated American* that "The Easter bonnet has long been recognized as woman's particular weakness" and became increasingly popular in the United States in the Victorian period, becoming part of a woman's fashion statement worn in the Easter Parade in the twentieth century. Here the Easter bunny obligingly helps a woman, seated before a pegboard wall full of hats, to select a new Easter bonnet, this one with a wreath of silk flowers, as her bemused friend looks on.

Easter hats could get really elaborate and decidedly over the top and this one seemingly throws everything else in the shade. The Easter parade in Boston on Commonwealth Avenue Mall was the perfect excuse to wear one of these hats, which was topped with flowers, leaves, tulle, and a giant bunny peeking out of it. The tradition reached its peak by the mid-twentieth century, and it was in 1948, the popular film *Easter Parade* was released starring Fred Astaire and Judy Garland. The title song includes the lyrics: "In your Easter bonnet, with all the frills upon it You'll be the grandest lady in the Easter parade." Irving Berlin.

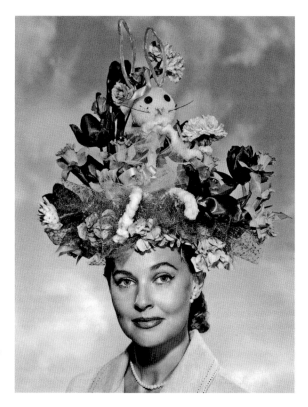

Dorsey Connors models in 1952 her new Easter bonnet, and perched atop the hat is a live duck in its lofty nest of plastic Easter grass. Easter bonnets can be both whimsical and fantastical, adding to the magic of the hat. Dorsey Connors began her career as one of the early female pioneers of television. Her first TV show began in 1948 on WGN-TV, a short program called *Personality Profiles*. For decades, she wrote a popular reader housekeeping hints advice column for the *Chicago Sun-Times*, which was also syndicated and ran until 2000.

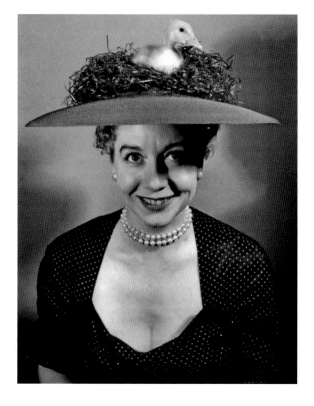

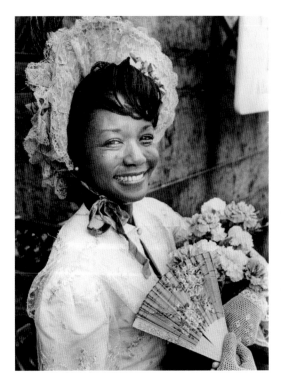

Dr. Mildred Fay Jefferson, a well-known and respected surgeon at the Boston University Medical Center, was awarded the prize in 1976 for the "Best Woman's Costume" in the "1876 Easter Parade" at the Boston Public Garden sponsored by Boston 200 during the bicentennial celebration. In a lace bonnet, crochet gloves, and holding a fan, Dr. Jefferson smiles for the camera. Dr. Jefferson was the first black woman to be graduated from the Harvard Medical School, the first woman to be graduated in surgery from Harvard Medical School, and the first woman to become a member of the Boston Surgical Society. (*Author's collection*)

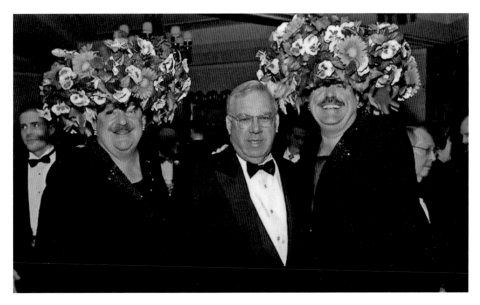

The Hat Sisters, John Michael Gray on the left and Tim O'Connor, flank Boston Mayor Thomas M. Menino in their over the top flower covered Easter bonnets. For thirty-two years, wearing matching hats and often matching dresses, they were fixtures on the Boston and Provincetown charity scene. Gilding the lily was literally where the hats began as there were Barbie dolls, balloons, star ships, waterfalls, and swans, sometimes at the same time. The hats could be 4 feet high and were often thematic for the occasion. During one of the inaugurations for late-Boston Mayor Thomas Menino, the hats were covered with pasted photos of him. As John Michael Gray said "When it stops being fun, the Hat Sisters will be no more."

6

THE EASTER PARADE

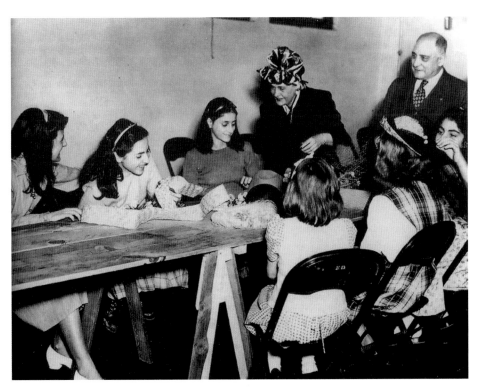

Madame Edmere, a noted milliner designer seen wearing one of her creations, demonstrates to the girls at the Home for Italian Children the fine art of hat making in 1948. Madame Edmere, whose name could be recognized by her uneven gait and penchant for French *haute couture*, brought along enough material, wire, ribbons, and bows so that each girl who participated in the demonstration would have an Easter hat of her very own to remember the occasion. Hats in the 1940s were not only a fashion statement but an integral part of high fashion. Seen on the right is Dr. John Sacco, physician to the home. (*Courtesy of the Italian Home for Children*)

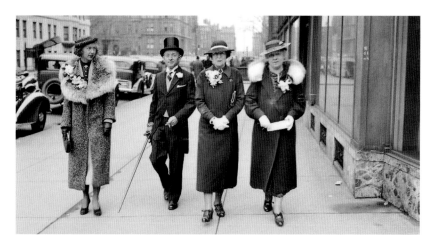

A foursome, with the women wearing gardenia corsages, walks along Berkeley Street in Boston's Back Bay in 1937 with a dapper gentleman in his morning jacket and vest, rep tie, boutonniere, and top hat holding a cane flanked by the women in their Easter finery. As Cleveland Amory said in *The Proper Bostonians*: "The one quality with which the female of the Proper Bostonian species has most impressed outsiders — once they are safely beyond the stage of merely staring at her antiquated hat, her stout shoes, and her generally severe exterior — is her incredible vitality." There is an age old story of a Boston Brahmin matron who is asked where women buy their hats. "Buy our hats?" replied the woman haughtily "We have our hats."

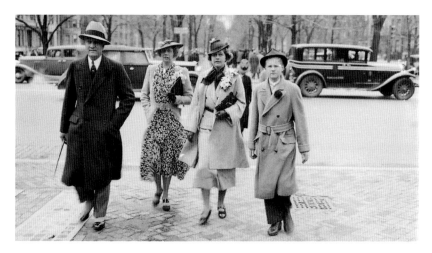

A family crosses Dartmouth Street as they walk along the Commonwealth Avenue Mall during the Easter Parade in 1938, which was after church services with people dressed in new and fashionable clothing. They would stroll from their own church to others to see the impressive flowers, and hopefully to be seen and their bonnets admired by their fellow strollers. Many hundreds of Bostonians participated in the Easter parade over the years and dressed in new and fashionable clothing, particularly ladies' hats, and they would strive to impress others with their finery. On the far left is the Hotel Vendome, designed by architect William Gibbons Preston, which was a residential apartment building, catering to long-term residents rather than visitors.

At Easter let your clothes be new,
Or else be sure you will it rue.

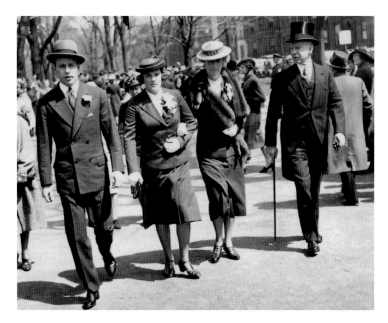

Joining in the Easter Parade on Commonwealth Avenue in 1940 was Christian A. Herter, then Speaker of the Massachusetts House of Representatives. Seen from left to right are Christian Herter, Jr., Adele Herter, Mary Pratt Herter, and Speaker Herter. Herter was later elected governor of Massachusetts serving from 1953 to 1957 and then as United States Secretary of State from 1959 to 1961 under President Dwight Eisenhower. In 1947, he founded the Middle East Institute with Middle East scholar George Camp Keiser and then served on the board of trustees of the World Peace Foundation.

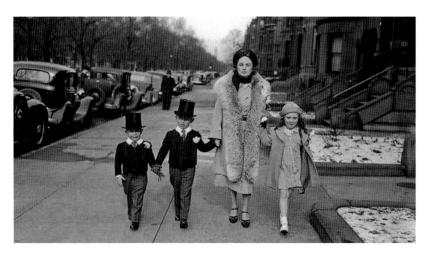

A well-dressed woman in a luxurious silver tip fox fur stole walks down Commonwealth Avenue on Easter Sunday in 1938 with her three children hand in hand. Though the daughter is well dressed in a dress, coat, hat, and gloves, her sons are turned out as miniature gentlemen in their dapper morning coats, Eton collars and rep ties, boutonnieres, and miniature top hats. The detachable stiff Eton collar had been introduced to British society in the nineteenth century and became a part of the school uniform of boys at Eton College. Quite the fashionable family on Easter Sunday in Boston.

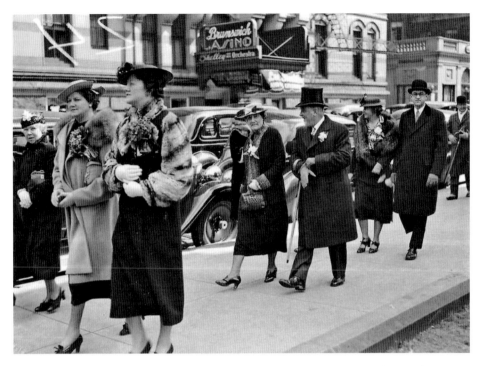

Having attended Easter Services at Trinity Church in Boston's Back Bay, these people walk along Clarendon Street headed toward the Commonwealth Avenue Mall for the Easter Parade in 1940. Women wear hats and corsages, white gloves, and their coats have mink, ocelot, chinchilla, and fox furs. In the distance is the entrance to the Brunswick Casino in the Hotel Brunswick. The Casino, which in the early twentieth century was a popular place after dinner, was an elegant club with dancing to the Shelley Orchestra.

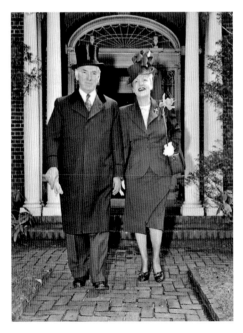

Top hatted Mayor James Michael Curley and his wife Gertrude Casey Dennis Curley leave their home on the Jamaicaway in Jamaica Plain in 1947 to attend Easter Sunday Mass at St. Thomas Aquinas Church. Curley was hailed as the "Peoples' Mayor" and as James M. O'Toole said "Surely there has been no more flamboyant political personality than James Michael Curley, who dominated politics in Boston for half a century. Whether as incumbent or as candidate, he was always there: alderman, congressman, mayor, governor. People loved him or hated him, but they could not ignore him ... and [he]presided over state and city during the challenge of the Depression, leaving behind impressive monuments in stone and public works. In the end, he even managed to enter American political mythology, remembered as much in his fictional incarnations as for his real life."

On Easter Sunday in 1963, the Sammarco Family posed in their Easter finery. In the huge straw hat is my mother, Mary Mitchell Sammarco; my father, Anthony Sammarco; Rosemary Sammarco; and yours truly. The photograph was taken in front of the home of my paternal grandparents, Luigi and Rose Giannelli Sammarco, on Albion Street in Medford before Easter Sunday dinner. (*Author's collection*)

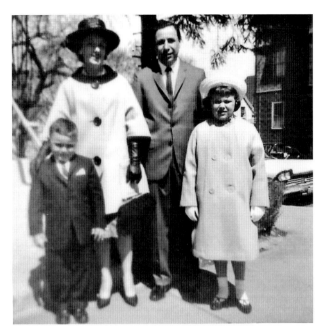

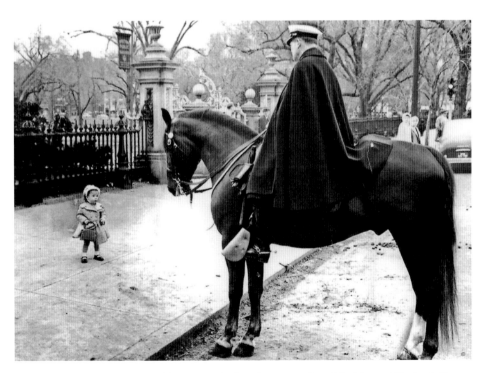

Little Elaine Martin stares up at Officer Benjamin Donahue, a member of the Mounted Boston Police, on his horse Justin's Son at the gates to the Public Garden at the beginning of the Easter Parade in 1958. The Martins were headed to the Easter Parade on the Commonwealth Avenue Mall but stopped at the gates to the Public Garden beforehand. The Boston Mounted Unit was started in 1873 to help with patrols and crowd control and was the oldest mounted police unit in the United States. The mounted officers were good for public relations as urban society saw few horses in the city by the 1950s. (*Courtesy of Frank Norton*)

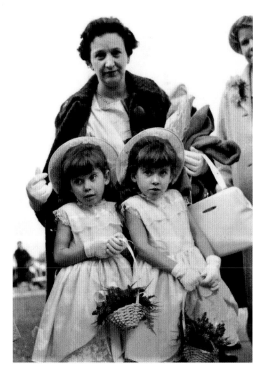

Left: These adorable twins are dressed in matching dresses, hats, and lace gloves and they carry small baskets of grape hyacinths on Easter Sunday in 1955. Seen from left to right are Jaqueline and Rosaline Keech, with their mother, Mary Natalie "Netty" Keech. (*Courtesy of Rozie Keech-Buccella*)

Twas Easter Sunday. The full-blossomed trees filled all the air with fragrance and with joy.
Henry Wadsworth Longfellow

Below: On Easter Sunday in 1951, Julia Oliveira O'Neil and Daniel O'Neil, seen on the left, brought their daughters to join 6,000 Bostonians marching in the Easter Parade. Dressed in identical Easter outfits of light green flared coats caught at the collar with black buttons and fetching flowered bonnets, are from left to right Frances, Danielle, Julie, Mary, Virginia, Evelyn, Maureen, Diane, Barbara, and Jane O'Neil. *Continues below...*

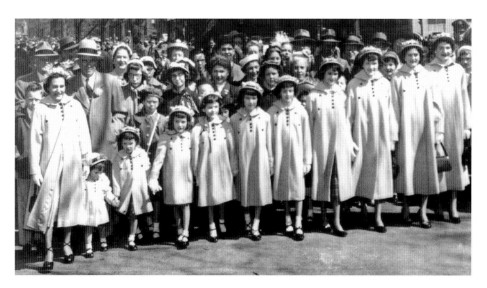

It was said that the O'Neils wanted their daughters to be dressed in matching finery so the family could stroll along the Commonwealth Avenue Mall in style alongside the Boston Brahmins who normally commanded the news. (*Author's collection*)

A mother's heart bent over the sewing machine,
embroidering love in each seam-twenty hands
working in unison with needles and thread.

Julie O'Neil

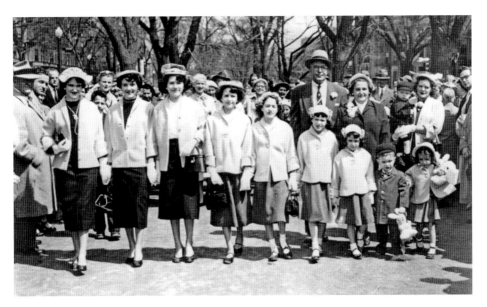

Among the 15,000 Bostonians parading on the Commonwealth Avenue Mall on Easter Sunday in 1955 was the now famous O'Neil family of Jamaica Plain. Seen from left to right in their Easter finery are Maureen, Evelyn, Virginia, Mary, Julie, Danielle, Frances, son Daniel Jr. holding an Easter bunny, and granddaughter Christa with an Easter bunny. On the right are Daniel O'Neil, Sr., and his wife, Julia Oliveira O'Neil, who made Boston's Easter parade an endearing annual tradition for their family until 1959 when Mr. O'Neil died. (*Author's collection*)

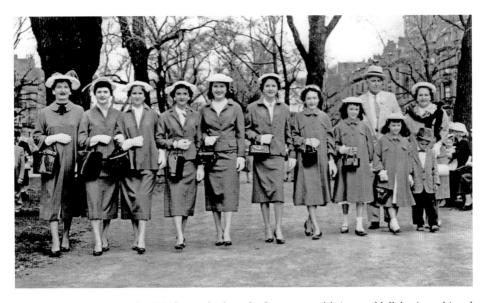

On Easter Sunday in 1957, the O'Neils parade along the Commonwealth Avenue Mall, having achieved local fame for not only participating in the Easter Parade for many years but appearing in their matching Easter finery and gloves that their mother annually made for them. From left to right are Jane O'Neil Deery, Barbara O'Neil Wampole, Maureen O'Neil Cloonan, and Evelyn, Virginia, Mary, Julie, Danielle, Frances, and Daniel O'Neil, Jr. Daniel and Julia Oliveira O'Neil, in Stone Marten furs, are on the far right. (*Author's collection*)

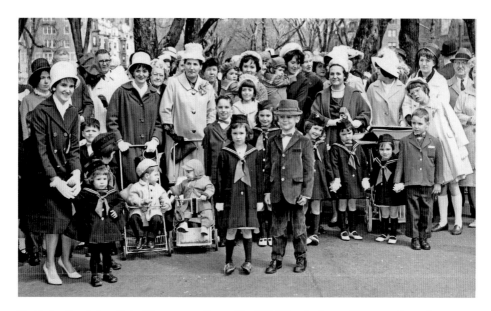

The Easter Parade in 1964 had three generations of the O'Neil Family along with many others who came to stroll along the Commonwealth Avenue Mall after church. On the right is Julia Oliveira O'Neil, with white hat, gloves, and pearls smiling as her daughters and her grandchildren pose for their photograph. Just as she had done for her daughters, she made the sailor outfits for her granddaughters and suits and bow ties for her grandsons, all of who continued the family tradition to the delight of Bostonians. (*Author's collection*)

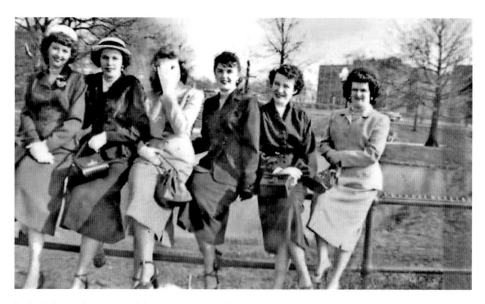

In their Easter bonnets and finery in 1951 are from left to right Mary McKernan, Barbara Gallagher, Anne Dineen, Marion Fennell, Rosemary Duffy, and Anne Flynn. (*Courtesy Chuck Bruen*)

Oh, I could write a sonnet about your Easter bonnet,
And of the girl I'm taking to the Easter parade.

Irving Berlin

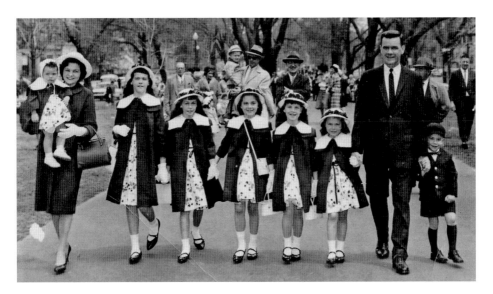

On Easter Sunday in 1962 on the Commonwealth Avenue Mall, seen from left to right are Agnes Houghton carrying Brenda, Rita, Maureen, Eileen, Kathleen, Sheila, Charles Houghton, and Charles Houghton, Jr. Maureen Houghton Foster remembers that "In the beginning my mother made our outfits. However, as more children were added to the family that became more difficult, so my mother found an elderly seamstress who lived nearby named Mrs. Church. We would go to her house to discuss the outfits and be measured, and I remember going into Chinatown with my mother to purchase the fabric. Mrs. Church did a wonderful job for a number of years." (*Courtesy Maureen Houghton Foster*)

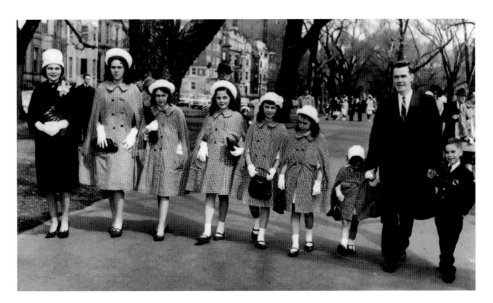

Seen on the Commonwealth Avenue Mall in their Houndstooth Cloak Sleeve coats and white bonnets are from left to right Agnes Houghton, Rita, Maureen, Eileen, Kathleen, Sheila, Brenda, Charles Houghton, and Charles Houghton, Jr. The idea of identical outfits must have stifled individuality and Maureen Houghton recounted that "as we got older we were allowed (usually at our insistence!) to wear different shoes, or a different hat, carry a different purse, or wear nylon stockings instead of white socks ... [and] my coat had a belt after I insisted that it not be completely identical to my sisters'!" (*Courtesy Maureen Houghton Foster*)

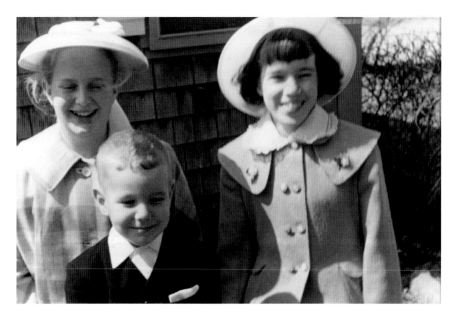

Posing in their Easter outfits on Easter 1961 are from left to right Teresa Wright, Bill Wright, and Cathryn Wright. (*Courtesy of Cathryn Wright*)

For I remember it is Easter morn, and life and love and peace are all new born. Alice Freeman Palmer.

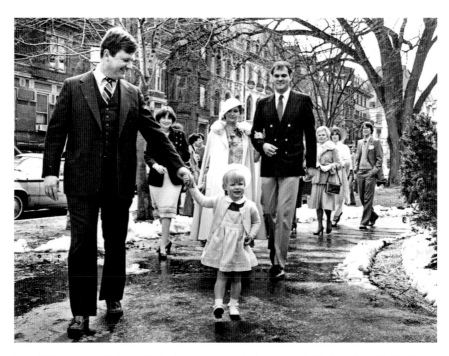

Fran O'Hara, on the left, strolls in the Easter Parade in 1972 with his daughter, Kelli O'Hara, something they did on an annual basis. Even by the early 1970s, the Easter Parade along the Commonwealth Avenue Mall in Boston's Back Bay brought hundreds to stroll in their Easter finery after church. Though there was melting snow, it did not deter fashionable Bostonians from continuing this long held tradition. (*Author's collection*)

6

EASTER SERVICES—HE IS RISEN

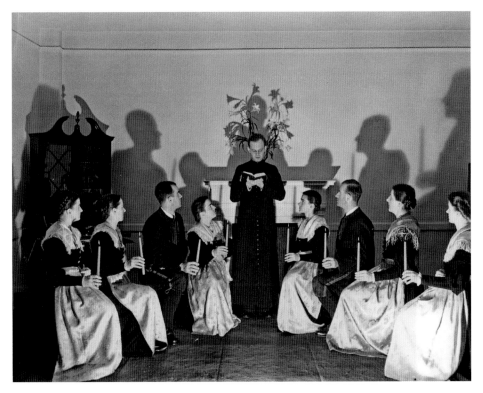

The Von Trapp Family Singers celebrated Easter in 1940 by singing hymns by candlelight under the direction of their conductor Dr. Franz Wasner, who was a Roman Catholic priest and chaplain to the family. The family choir was headed by Baroness Maria von Trapp and their singing was acclaimed by music critics. Seen from left to right and dressed in traditional Austrian outfits are Johanna, Agatha, Werner, Martina, Dr. Franz Wasner, Maria, Rupert, Baroness Maria Augusta von Trapp, and Hedwig von Trapp. Maria von Trapp wrote *The Story of the Trapp Family Singers*, which was published in 1949 and inspired the 1959 Broadway musical *The Sound of Music* and its 1965 film. (*Author's collection*)

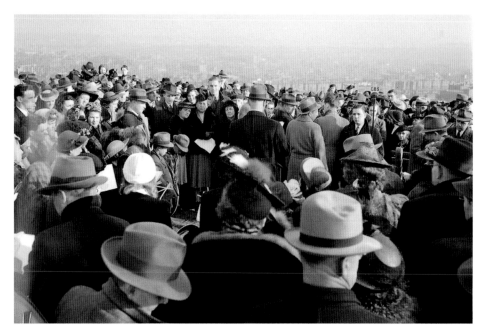

Hundreds of people gathered in 1938 to greet the rising sun at an Ecumenical Easter Sunrise Service sponsored by WEEI/CBS Radio at Mount Hood in Melrose, Massachusetts. The Town of Melrose had recently acquired 210 acres of land and began the development of the Mount Hood Park and golf course in the 1930s and the park and golf course were completed by the Works Progress Administration in 1937. Here, the worshipers greeted the sunrise in prayer and song, and as the sun rose, the panoramic views of Boston in the distance was incredible.

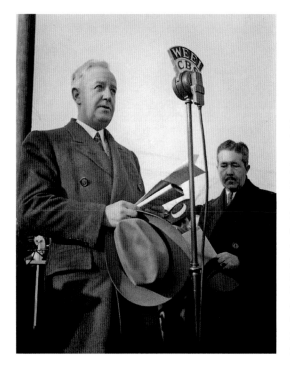

Reverend Eugene Crary Greiner of Winchester and Lloyd Gould Del Castillo, on the right, led the WEEI/CBS Easter Sunrise Service at Mount Hood in Melrose, Massachusetts, in 1938. Del Castillo was one of the original silent film organists who established the first school for theatrical organists in Boston and his illustrious career as radio personality, organist, and arranger made him a well-known personality in the 1930s, including the conducting of his own works with the Boston Pops Orchestra. After moving to Los Angeles in 1941, he composed music for the radio dramas *Stars Over Hollywood*.

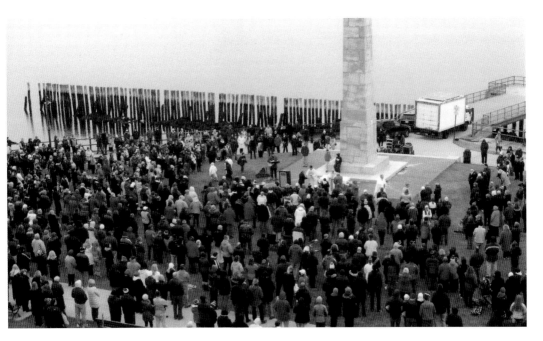

Sunrise Worship at Castle Island in South Boston is a magical place at dawn. Reverend Robert E. Casey, the pastor of South Boston's St. Brigid Church, began the 2016 Sunrise Easter Mass with an opening hymn, "Morning Has Broken." There was a crowd of perhaps as many as 2,000 that gathered for Easter worship on Castle Island, on the northeast rampart of Fort Independence to worship while the sun rose over Boston Harbor. The granite monument was erected to Donald McKay, the famous shipbuilder from East Boston, where the altar was setup and the services were held.

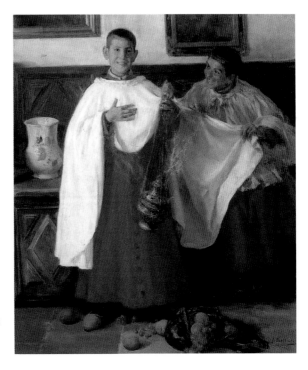

Monaguillos (*Altar Boys*) was painted by Jose Benlliure y Gil (1858–1937) who was a well-known Spanish painter who he painted two altar boys clowning before services. The boy in the foreground has a large surplus over his red robe and holds a thurible fragrant with smoke as his friend holds a fold of the cassock. The use of incense adds a feeling of solemnity to the Mass and symbolically purifies all that it touches, so it is in marked contrast to the altar boys' behavior. The artist was appointed as honorary president of the Circle of Fine Arts in Valencia (Cercle de Belles Arts), and became director of the Museu de Belles Arts de Valencia, a position he held until 1924.

At the Easter Vigil, five grains of encapsulated incense are embedded in the paschal candle. These five grains of incense represent the five wounds of Jesus Christ, one in each hand, one in each foot, and the spear thrust into His side.

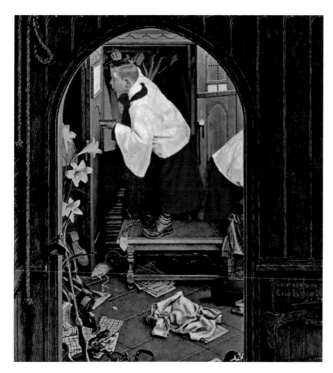

Choir Boy Combing Hair for Easter was painted Norman Rockwell of a choirboy looking in a small mirror and preening before Easter Sunday worship began. The painting appeared on the cover of *The Saturday Evening Post* published April 17, 1954. Recalling his days in the church choir, Rockwell wrote: "On Sundays in the choir room we roughhoused and shouted and wrestled while donning our cassocks and surplices. The sexton, poking his head around the door, would yell that it was time for us to enter the church. Plastering down our cowlicks, pushing, jostling, we'd form two lines. Then, suddenly, we'd grow quiet and, solemn-faced, march into the church"

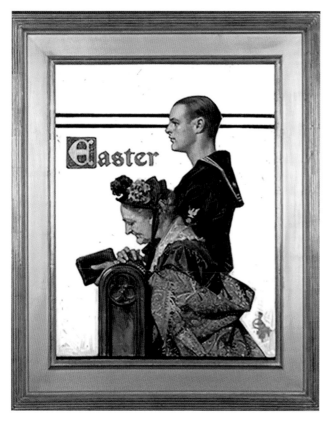

Easter was painted by Joseph Christian Leyendecker for the cover of *The Saturday Evening Post* magazine in 1918. Leyendecker's popularity as an illustrator paralleled the modernization of *The Saturday Evening Post* from 1899 to 1937 under George Horace Lorimer, who sought to broaden readership by appealing to hardworking, patriotic, practical, and wholesome middle-class men and women. During World War I, in addition to his many commissions for magazine covers and advertisements, he also painted recruitment posters for the United States military and the war effort. Here, a soldier returning from World War I joins his mother at Easter Sunday services, with his mother giving thanks for his safe return.

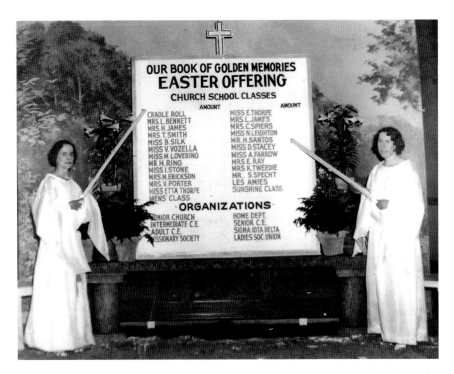

A dramatic and novel Easter Offering was presented in 1938 at the Union Square Baptist Church on Walnut Street in Somerville, Massachusetts, by the Rev. Harold Willard Arthur; the church was founded in 1885 and was a large shingled Romanesque Revival church with a soaring bell tower and had a large congregation. The large electrically lighted board of "Our Book of Golden Memories Easter Offering," surmounted by an electric cross, was on the altar and two "angels," Greta Long on the left and Beatrice Metts hold electrified wands that would illuminate the book as members of the congregation brought up their offering and placed it in the Easter basket to support the church school classes and organizations. The Walnut Street Park is on the site of the church today.

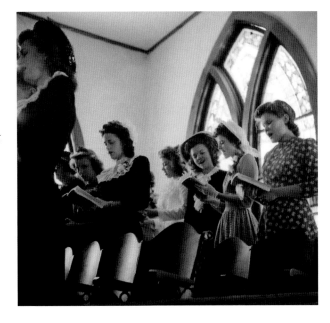

Easter Sunday worship services at the Union Square Baptist Church were filled with joyous hymns of the Resurrection of Jesus Christ. Here a group of women dressed in their Easter finery and Easter bonnets sing in the church balcony framed by a large lancet stained glass window. The hymn Christ, the Risen King might have been sung that morning.

Rise O Church and lift your voices
Christ has conquered death and hell
Sing as all the earth rejoices
Resurrection anthems swell
Come and worship come and worship
Worship Christ the Risen King

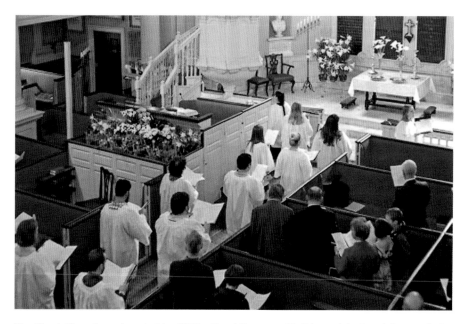

The King's Chapel was founded in 1686 by Royal Governor Sir Edmund Andros (1637–1714), the governor of the Dominion of New England, as the first place of Anglican worship in Massachusetts Bay Colony. The original wood church was replaced in 1754 by a granite church designed by Peter Harrison at the corner of Tremont and School Streets adjacent to the King's Chapel Burial Ground. It was literally, as an Anglican Church, the "King's" own chapel in Boston and a Bible, silver communion service, cancel table, and vestments were given by the monarch. Here on Easter Sunday the choir processes down the main aisle with box pews on either side.

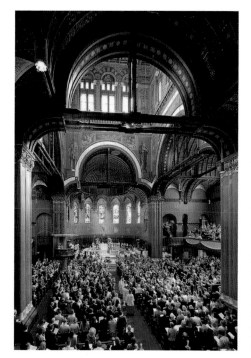

Trinity Church, when it was consecrated in 1877, was considered one of the most important buildings in Boston and was in 1885 included as one of the ten most important buildings in the United States by the American Institute of Architects. Designed by Henry Hobson Richardson of Gambrill & Richardson, its congregation had moved from downtown Boston after the Great Boston Fire of 1872 to Art (now Copley) Square in Boston's Back Bay. The interior, seen on Easter Sunday, with interior decorations by John LaFarge and windows designed by John LaFarge and Edward Burne-Jones, executed by the studio of William Morris, the church is not just locally but nationally important as one of the most significant buildings in the United States.

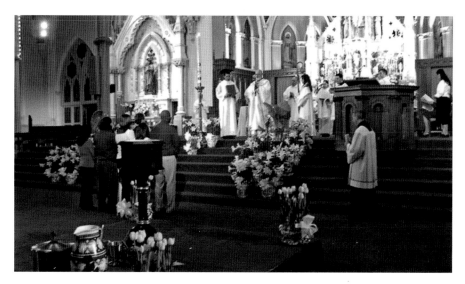

The Cathedral of the Holy Cross was once the largest Roman Catholic church in New England and was designed by Patrick C. Keeley using the popular Roxbury pudding stone. With anti-Catholic sentiments a recent memory, the Gothic Revival edifice was intentionally massive, a statement that the Catholics of Boston were here to stay. The magnificent altar of the Cathedral of the Holy Cross was designed by Patrick Keeley (1816–1896) and carved from white marble. The church interior is grandly impressive, and is divided by lines of bronzed pillars, which uphold a lofty clerestory and an open timber roof and the ceiling and tracery are carved of three shades of oak, and an immense inlaid wood cross adorns the transept ceiling. Here Seán Patrick O'Malley, archbishop of Boston, is seen on the flower decorated altar, on Easter Sunday in 2015.

New Old South Church was organized in 1669. Its present building in Boston's Back Bay was designed in the Venetian Gothic Revival style by Charles A. Cummings and Willard T. Sears, completed in 1873, and later embellished by Allen and Collens in 1937 when the campanile was rebuilt and a new chapel was built in memory of the Reverend George Angier Gordon. Seen here on Easter Sunday 2016, the interior of the church complimented the Ruskinian Gothic Roxbury pudding stone exterior, and expressed Ruskin's ideal that it is "in art that the heart, the head, and the hand of a man come together." With an early twentieth-century remodeling by Louis Comfort Tiffany, Old South's stained-glass windows were covered by insets of translucent tinted purple glass and the original polychrome stenciled plaster walls were painted purple, and then stenciled in a series of geometric patterns with metallic silver paint intended to appear as mother of pearl inlay.

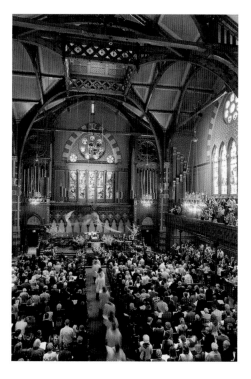

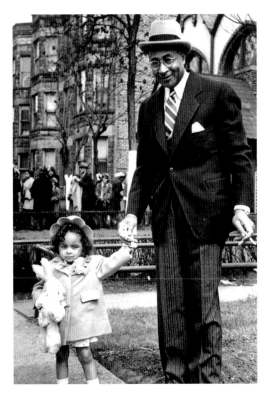

This dapper grandfather, in his morning coat with pocket handkerchief, smart woven silk tie, striped trousers, and fedora, seems as pleased as punch with his adorable granddaughter in her Easter outfit and bonnet, clutching a stuffed Easter bunny after Easter services at St. Ann's Church on St. Stephen Street in Boston's Fenway.

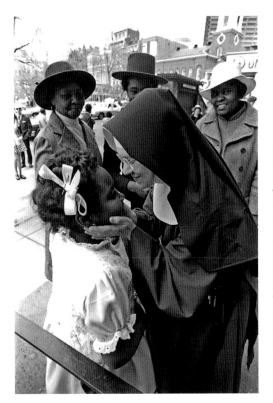

Sister Rhoda, a sister of the Society of St. Margaret, embraces a child on Easter Sunday in 1973 in front of the Cathedral of St. Paul on Tremont Street in Boston, across from the Boston Common. Originally located on Louisburg Square on Beacon Hill in Boston, the society had contiguous townhouses used both as a convent and a small private hospital and chapel. In 1928, the work of the sisters grew in earnest when they took charge of L'Ecole de la Cathedrale de la Sainte Trinite, Port-au-Prince, Haiti, and have sustained it ever since. These women in the background, all from Haiti, had a long and enduring connection with Boston and the Sisters of St. Margaret.

Keep alert, stand firm in your faith, be courageous, be strong. Let all that you do be done in love. I Corinthians 16:13-14.

8

Easter Baskets, Easter Candy, and Easter Seals

The tradition of exchanging Easter baskets can be traced back to German immigrants in the nineteenth century and their lore of a mythological rabbit bringing eggs, treats, and toys. Here, a trio of little girls in fetching Easter bonnets eagerly contemplate their wide woven wicker baskets of Easter eggs and candy. In 1873, J.S. Fry & Sons of England introduced the first chocolate Easter egg in Britain. Manufacturing their first Easter egg in 1875, Cadbury created the modern chocolate Easter egg after developing a pure cocoa butter that could be molded into smooth shapes and the public was enthralled.

Left: A velvet frock coated Easter Bunny visited the Italian Home for Children in 1957, and this little boy greets him unabashed awe. Sister Mary Beatrix, seen on the right, oversaw the fun afternoon for the children, and not only did they greet the Easter bunny, but there were treats and candy. From its founding until the late 1960s, the home cared for approximately 115 children annually and the average age was ten and the average stay was one year, although it could range from a few months to a decade. (*Courtesy of the Italian Home for Children*)

Below: Girl Scouts from Roslindale, Massachusetts, wearing their uniforms, white blouses, and sashes studded with awards and badges, visited with the children at the Italian Home for Children in 1950, bringing cellophane wrapped Easter candy as gifts for them. The Girl Scouts offer the best leadership development experience for girls in the world, and this was an important way for them to give back to the community. (*Courtesy of the Italian Home for Children*)

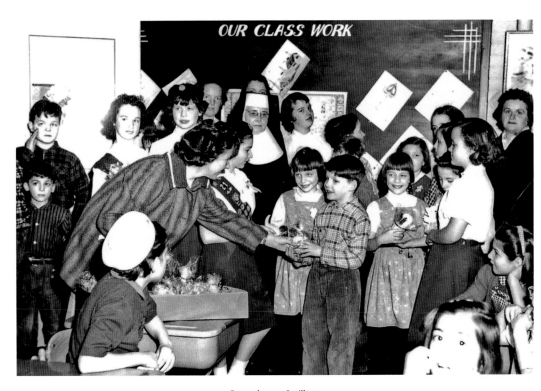

On my honor, I will try:
To serve God and my country,
To help people at all times,
And to live by the Girl Scout Law.

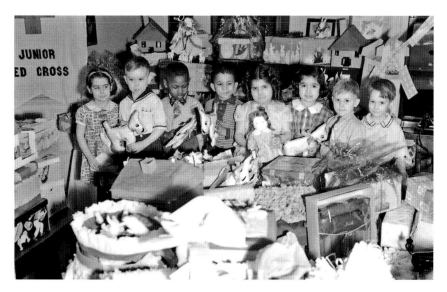

The Junior Red Cross was established in 1922 in the hope of encouraging younger generations to cultivate their humanitarian spirit by understanding the Red Cross principles and ideas, and they provided these lucky children with toys, dolls, stuffed animals and Easter baskets. During the mid-twentieth century, Junior Red Cross programs continued with children working in relief efforts during the Great Depression, helping to distribute surplus food, canning vegetables, and collecting clothing for distribution. When World War II began, the nearly 20 million members of the Junior Red Cross joined with the adult Red Cross volunteers to help those in need. Here a group of happy children receive toys and Easter baskets in 1942.

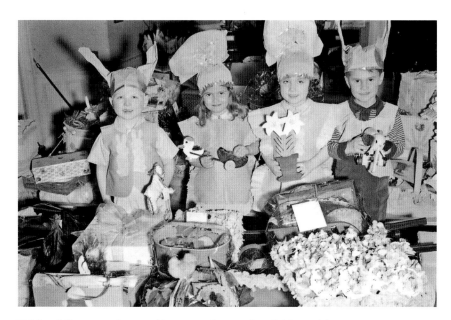

Holding dolls, toys, and a paper lily in a pot, these smiling children celebrate at an Easter party in 1935 with fancy paper hats sponsored by the Junior Red Cross in Boston. Youth civic engagement, led by the Red Cross and many other volunteer organizations in Boston, proved vital to our national interest and to the development of young women and men as the future leaders of society.

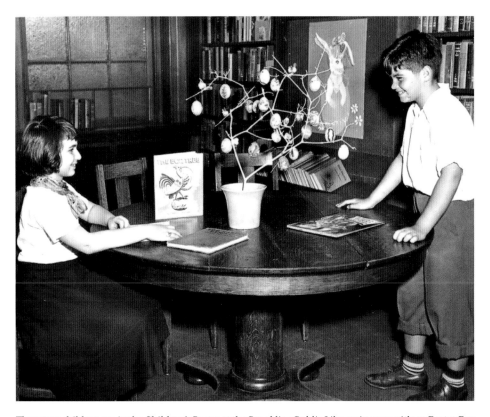

These two children are in the Children's Room at the Brookline Public Library in 1950 with an Easter Egg Tree and a copy of *The Easter Tree*, written by Katherine Milhouse, which was awarded the Caldecott Medal in 1951. In the book, Milhouse writes about a Pennsylvania Dutch family and their Easter celebration with Easter eggs found in the family attic that had been painted by their grandmother when she was a little girl. The family hung the decorated eggs from the branches of a tiny tree which became an Easter Tree, and so began a very special Easter tradition. The art in the book has bright tempera paints and the traditional Pennsylvania Dutch hex designs, which brought to life the bold borders and vibrant pages of the book.

Left: By the mid-1950s, department stores and shopping malls began to advertise that the Easter bunny would be visiting during the weeks leading up to Easter. Here the "Jellybean Patch," with its AstroTurf lawn and Styrofoam egg plants, was where the Easter bunny was ensconced in a padded chair made out of a huge half egg shell with larger than life colored eggs that proved the perfect place for a child's photograph to be taken as a memento. Major department stores such as Jordan Marsh, Filene's, Raymonds, and Gilchrist in Boston all had Easter Bunnies that the children could have their photograph taken with.

A dapper Richard "Turk" Gonsalves holds the hands of his daughters, Jane Gonsalves on the left and Ann Gonsalves Cathcart at Easter 1964; the daughters are dressed in double breasted white wool jackets, white gloves, bonnets, and black Mary Jane shoes. Gonsalves, a native of Madeira in Portugal, was a junior engineer aide for the Commonwealth of Massachusetts Highway Department and served on the New Bedford Redevelopment Authority from 1963 to 1968. Jane Gonsalves would also became active in politics and in 1993 she ran for the Ward 5 City Council seat and was elected from a field of five candidates. She said "It has been a wonderful experience, despite the stress that sometimes accompanies public service. I know that I have made a difference for people and neighborhoods during my tenure."

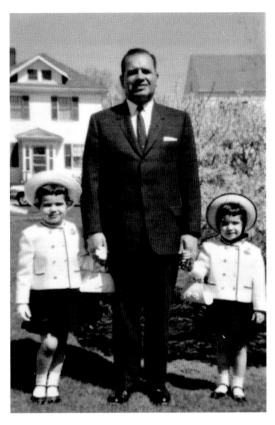

Martin Lee Klug, on the left standing on a tree stump, and his brother, Richard Klug, pose with their dapper bow tied father, Leo Klug, on Easter Sunday in 1957. The boys said that they always looked forward to Easter in the 1950s when they would wear their new outfits to church, then they would get candy filled Easter baskets before going to their grandparents' house for Easter dinner.

Baby animals born in the springtime have always been child-friendly motifs, especially at Easter. A young boy and girl look at the adorable baby chicks and white rabbits through a storefront window dressed in holiday decorations. Many children would receive these as part of their Easter gifts in the 1950s; however, because Easter chicks were often purchased at the spur of the moment, many new owners forget about the special feeding and care their new pet required.

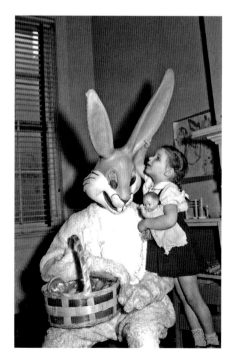

A young girl who was a student at the Perkins School for the Blind in Watertown, Massachusetts, reaches to feel the Easter Bunny's ear as she clasps her doll to her chest. The Easter Bunny has a large wide woven basket filled with treats for the children that he had come to visit. (*Courtesy Perkins School for the Blind*)

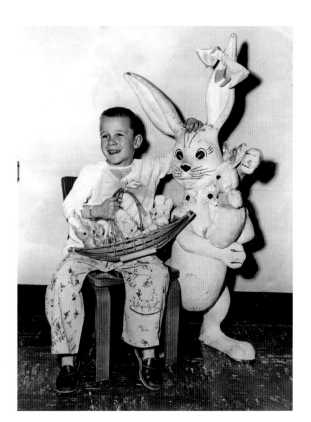

Paul McElroy, aged five, was a patient at the Carney Hospital in Dorchester in March 1956 when he attended an Easter party in the children's ward. He is seen in the children's ward play room with his arm around a life sized Easter bunny and holding an Easter basket filled with stuffed animals and chocolate Easter eggs. Even recovering from an operation felt better with a chocolate Easter egg or two. (*Author's collection*)

The Easter bunny holds this smiling young boy on his lap when he visited the children at the Home for Italian Children, and the boy holds a chocolate bunny rabbit given from the basket on the piano bench. The influenza epidemic of 1918 devastated Boston's North End, leaving hundreds of orphans. The home was opened in 1921 with thirty girls aged four to fourteen in residence, and admission was broadened to include boys in 1929. Over the years, the home changed the nature of its services, from Italian children to children of all races, nationalities, and religions, and from custodial care to treatment. (*Courtesy of the Italian Home for Children*)

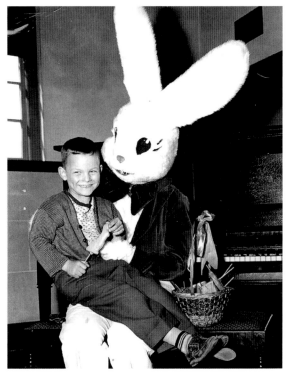

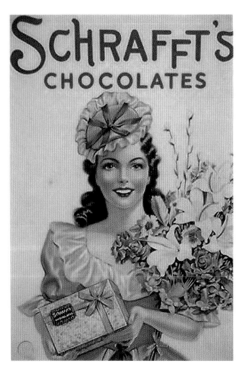

Schrafft's Chocolate Company was founded by in 1861 by William F. Schrafft who began by making gumdrops and candy canes. A landmark in Sullivan Square in Charlestown, Schrafft's in their heyday was the largest general line confectioner in the country and employed over 1,600 workers including my great uncle, Dominic Giannelli, a master candy maker. The famous Schrafft's building, built in 1928, has a large neon sign that is still a landmark in the city. Frank Shattuck took over the company in 1898, and would expand the company to include restaurants, known for their ice cream, which grew to include fifty-five restaurants and candy stores by 1968. Here a woman in her Easter bonnet holds a box of Schrafft's Assorted Chocolates, a welcome Easter gift indeed.

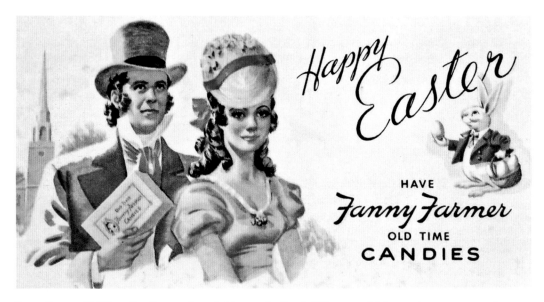

Fanny Farmer Old Time Candies was founded in 1919 by Frank O'Connor, which grew to over 400 candy stores that offered gleaming white counters with many delicious candies and interesting nutmeats from all corners of the world. Fanny Farmer was named in honor of culinary expert Fannie Farmer, who actually had nothing to do with the candy stores, nor were her recipes used for the candy. O'Connor realized that the pun on the name was a perfect way to market the candy, and it subtly suggested reflected glory. Fannie Farmer's high standards of quality. In fact, Fannie Farmer's photograph was often used on boxes of candy that claimed "Everybody loves Fanny Farmer Candies because they are always fresh." This couple, dressed in the period of the 1830s, stand in front of the Old North Church holding a box of Fanny Farmer Candy on the box top.

Whitman's Chocolates was claimed to be "The season's most popular messenger." Founded in 1842 by Stephen F. Whitman, he opened a small "confectionery and fruiterer shop" and offered a variety of sweets. In 1854, Whitman's Choice Mixed Sugar Plums became the first packaged confection in a printed, marked box. The Whitman's Sampler Box began in 1915 and quickly became the most popular assortment in the Whitman's line of candy. In recognition of its standing, in 1915 the "Messenger Boy" chocolate was added to the selection of chocolates in the box, and it became a symbol of quality, and a registered trademark of candy in the Sampler. This woman, in her Easter bonnet designed by Sally Victor who was a popular innovator of millinery, says "A woman never forgets the man who remembers," which was a major 1939 marketing campaign.

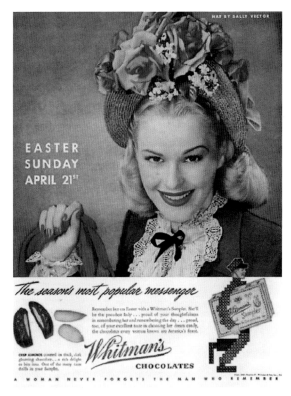

A child dressed in an Easter bunny outfit holds an Easter egg that opens to show a selection of boxed Whitman Chocolates. They suggest "Easter greetings to some particular one, with a box of Whitman's Chocolates, known and welcomed by everyone." The Whitman's Sampler, an assortment of boxed chocolates, would reach a level in American pop culture in that it was mentioned in many television shows, movies, and the like. The candies' flavors can be determined by their shapes as a square shape denotes caramels, a rectangle means nougat filling; oval chocolates typically contain fudge, the soft-centered flavors, including cherry cordials, are round and nut clusters are easily identified by their rough surfaces.

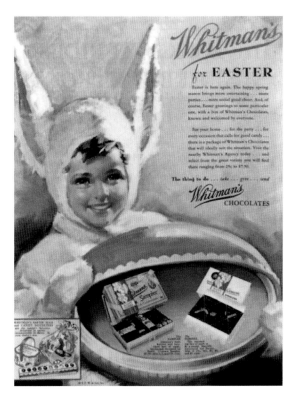

Phillips Chocolates was founded in 1925 by Phillip and Concettina DiMare Strazzula and they began selling chocolate out of their home in the fall of 1925, eventually opening a shop in Belmont in 1935 known as Phillips Sweets. Now located on Morrissey Boulevard in Dorchester, Massachusetts, the Colonial-inspired candy shop was opened in 1952 by brothers Matthew and Philip Strazzula and brother-in-law Joseph Sammartino. The quality of the chocolate is high and the selection incredible from the salted caramels, nonpareils, the signature chocolate turtles, handmade old fashioned fudge, and, my favorite, the Figaro, dark chocolate filled with a creamy hazelnut paste. Seen making candy are Tony Cavaretta on the left and Matt Strazzula. Today, Phillips Chocolates is Boston's oldest chocolatier and is run by the third and fourth generation cousins Joseph Sammartino, Jr., and Philip Strazzula III and Joe's son, Matthew Sammartino. (*Courtesy of Phillips Chocolates*)

Winston Flowers on Newbury Street in Boston's Back Bay has become an enduring tradition for high-quality flowers and floral design. In 1944, Robert Winston and his son, Maynard Winston, began by wheeling their pushcart of flowers on to Boston's fashionable Newbury Street, selling cut flowers in front of the Ritz-Carlton Hotel. By the 1950s, Winston was one of the first florists to begin importing flowers from overseas and Bostonians were enthralled with exotic varieties of freesias, lilacs, and tulips flown in from Holland exclusively for Winston Flowers. Here Maynard Winston shows daffodils to two women in front of their store at 131 Newbury Street. (*Courtesy of Winston Flowers*)

 The Earth laughs in flowers. Ralph Waldo Emerson.

Surrounded by Easter Lilies at the Winchester Conservatory on Cambridge Street in Winchester, Massachusetts, at Easter 1953 are from left to right Gayle Porter, Deborah Wittaker, and David Wittaker, all from Winchester. One of many farms in Winchester, this was at the intersection of Cambridge and Wildwood Streets, which was originally known as the Little Farm that subsequently became the Winchester Conservatories, a greenhouse for flowers. Today this is Mahoney's Rocky Ledge, the original location opened in 1959 by Paul Mahoney of a family operated chain of garden centers with a wide range of plants and supplies.

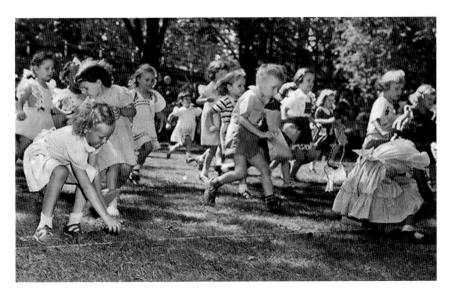

Easter Egg Hunt is an Eastertide game during which decorated and colored Easter eggs are hidden for children to find. The egg has long been considered a symbol of the rebirth of the earth in pre-Christian celebrations of spring and since the seventeenth century, the idea of the Easter bunny bringing the Easter eggs has been known and these gleeful children race to collect the eggs in a basket. When the hunt is over, prizes may be given out for various achievements, such as the largest number of eggs collected, for the largest or smallest egg, or for the most eggs of a specific color.

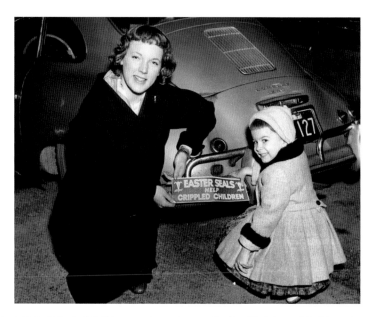

Easter Seals Help Crippled Children, and seen her are Tenley Albright and Gail Ann Arsenault, an Easter Seal rehabilitation treatment recipient, holding a bumper strip they were attaching to Miss Albright's 1957 Porsche 356A 1600cc Speedster. Tenley Albright was not just an Olympic skating champion in 1956, the 1952 Olympic silver medalist, the 1953 and 1955 World Champion, the 1953 and 1955 North American champion, and the 1952–1956 United States national champion, but she served in 1957 as chairman of the state-wide seal campaign. As Paul Medeiros said, Easter Seals makes "profound, positive differences in people's lives every day with our personalized programs and services that are constantly responding to the evolving unmet needs of people in the state." (*Author's collection*)

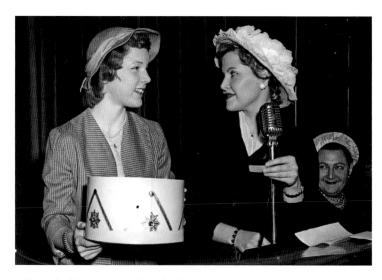

The Boston Easter Seals Bonnet Brunch was held in April 1957 with Tenley Albright, the Massachusetts chairman of the Easter Seal Campaign, drawing as a door prize, which was a new Easter bonnet for Rubye Graham, seen at the microphone. Miss Graham was the fashion director of the Millinery Institute of America, which had presented the luncheon and fashion show at the Boston Club. On the right is Virginia Harris, the regional director of the Boston Fashion Group. (*Author's collection*)

9

EASTER SUNDAY DINNER

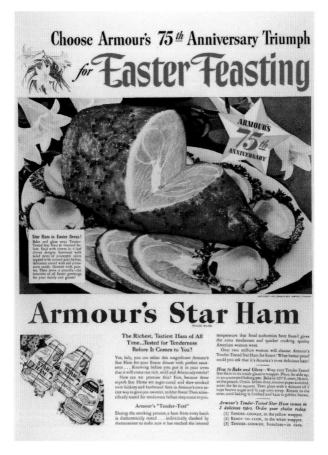

Seen here in Easter Feasting, Armour's Star Ham was advertised as the company's seventy-fifth anniversary Triumph and was said to be "The Richest, Tastiest Ham of All Time ... Tested for Tenderness Before it Comes to You!"

Armour was founded in Chicago in 1867 by the Armour brothers led by Philip Danforth Armour. In the early 1920s, the company was sold to Frederick H. Prince and was one of the largest American firms through the Great Depression and the sharp increase in demand led to its expansion across the United States. This clove studded ham was perfect for Easter dinner and came in three delicious types: tender cooked, ready to cook, or tender cooked boneless.

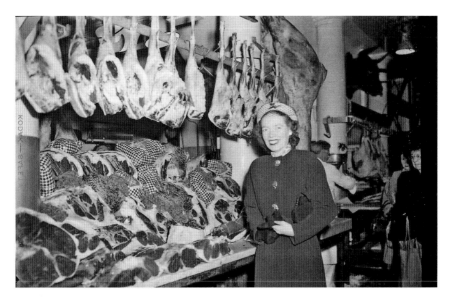

This woman, who is remarkably well dressed to do her grocery shopping, stands in front of the meat counter at Thresher and Kelley at Quincy Market in Boston. With hams, legs of lamb, and a side of beef hanging directly behind her, the choices were endless to provide a delicious Easter dinner for family and friends. Quincy Market, named for Boston mayor Josiah Quincy, was opened in 1826 directly behind Faneuil Hall to accommodate the need for more goods under one roof and convenient shopping and had individual stalls of purveyors that was opened six days a week.

Discussing her Easter meat order with John Kelley, partner of Eugene H. Thresher of Thresher and Kelley Meats at Stall 73 at Quincy Market in Boston, is a woman who could choose from a wide variety of meats, from pork, beef, lamb, and poultry. Thresher and Kelly was said to be one of the finest purveyors of fresh and cured meats in Quincy Market. On the left was a sign "Drawing to Win a Bear Rug" over the bear's head, surrounded by a laurel wreath, of the fur rug surrounded by shoulder hams, Virginia hams, legs of lamb, and beef.

This fruit and vegetable store on Prince Street in Boston's North End really got in the Easter spirit by spelling out "Happy Easter" in fresh eggs laid on a hay bale. With stuffed Easter bunnies and chicks, it was a whimsical way to celebrate the Easter season, but also a sure way to catch the passerby's eye to stop in the store.

Julia Child, wielding a large cook's knife in her hand, was a well-known chef that through her cooking show *The French Chef* on WGBH television program taught Bostonians how to not only cook *à la française* but how to enjoy the process and entertain family and friends with well-prepared Easter dinners. Here she has a lineup of chickens that she prepares to be roasted for Easter dinner. It was thanks to her culinary skills that Bostonians' gastronomic delights and pleasure in eating are due.

How will you cook your Easter Star Ham?

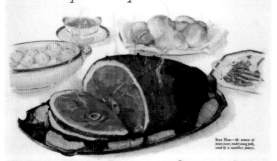

Easter with a Star Ham, fragrant in its brown jacket of glazed sugar studded with cloves! What a feast!

And here a suggestion for your "Easter Star Ham"—Boil a "Star" ham ten minutes, then simmer 3 hours. Take ham from water and remove skin. Bake slowly at a temperature of 350° F., or a moderate oven, for one hour, fat side up. Baste with mixture of 1 cup pineapple juice, 1 cup ham liquor, and 1 teaspoon mustard. Sprinkle brown sugar over fat, dot with cloves, and continue baking without basting until ham is done. Serve with sauted pineapple rings.

The certainty of delicious results from an Armour Star Ham is absolute. That is established in the Armour Kitchen in Chicago—the most vital function in the whole Armour effort

to make it true that "Armour on a food product is an assurance of quality."

The domestic science experts in charge of this kitchen are wise in the knowledge of what you and your family delight to put on your table—and their word is final.

Out of the experience and knowledge of these culinary experts has come a wonderful cookbook, "Sixty Ways to Serve Ham." The Easter recipe given above is one of these sixty ways. The book is free—send for your copy.

For sixty years Armour and Company have been perfecting methods to safeguard your meat supply—the most important item in the daily diet. As they have perfected processing so they have

developed distribution through thousands of dealers serving millions of homes—virtually extending the benefits of the Armour Kitchen into every neighborhood. It is for such services as these that Armour and Company have won their acknowledged position among the great provisioning organizations of the world. Armour and Company, Chicago.

Send the coupon for a free copy of "Sixty Ways to Serve Ham," an unusual recipe book prepared by the Armour Kitchen.

Dept. 4 B, Div. Food Economics
Armour and Company, Chicago, U. S. A.
Please send me the Free Recipe Book, "60 Ways to Serve Ham."
Name
Address

"How will you cook your Easter Star Ham?" asked Armour in this advertisement from 1928. The Armour Star Ham was claimed to be the utmost in meat; sweet, tender young pork, cured by a matchless process. Armour, which had been perfecting methods to safeguard your meat supply, offered a complimentary cookbook, *Sixty Ways to Serve Ham*. "Armour on a food product is an assurance of quality," and the Star Ham is fragrant in its brown jacket of glazed sugar studded with cloves.

THE MEAT MAKES THE MEAL

SWIFT'S PREMIUM: *brand name of the finest meats*

Swift's Premium advertised their company as the "brand name of the finest meats" beginning in 1931 under its Select, Premium, and other Swift labels. In this advertisement from 1938, it offered cooking suggestions for preparing an Easter ham and a leg of lamb. Gustavus Franklin Swift began his own meat-market business in 1855, and he is credited with the development of the first practical ice-cooled railroad car, which allowed his company to ship dressed and prepared meats to all parts of the country and abroad. By 1900, his company had grown into one of the nation's main meat packing companies, with a reach throughout the United States.

Ever since Clarence Birdseye developed a process for freezing foods in small packages suitable for retailing, Birds Eye Frosted Foods has offered a time saving addition to Easter dinner with vegetables such as squash, cauliflower, cut corn, and a variety of other vegetables and frozen fruits, which preserved the original taste and texture of a variety of foods that you might serve them with their Birds Eye Roast Chicken. A government-inspected Grade A chicken that was ready to be roasted, families offered an "Easter Salute to the noblest roaster of them all!" With a money back guarantee 'there's not one penny's excess waste to this Birds Eye Roaster.'

Families would join one another for Easter Sunday dinner after church, joining in the celebration of the Resurrection of Jesus. In this photograph from 1967, it seems as if this family is subliminally recreating Norman Rockwell's iconic painting *Freedom from Want*, part of his "*Four Freedoms* series," with an elderly couple standing at the head of the dining room table as a baked ham is placed on the table to be carved for their family.

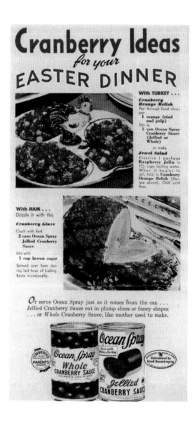

Cranberry Ideas
for your
EASTER DINNER

With TURKEY . . .

Cranberry Orange Relish
Put through food chopper:
1 orange (rind and pulp)
Stir in
1 can Ocean Spray Cranberry Sauce (Jellied or Whole)

or make

Jewel Salad
Dissolve 1 package Raspberry Jello in 1½ cups boiling water. When it begins to jell, fold in Cranberry Orange Relish (Recipe above). Chill until firm.

With HAM . . .
Drizzle it with this

Cranberry Glaze
Crush with fork
2 cans Ocean Spray Jellied Cranberry Sauce
Mix with
1 cup brown sugar
Spread over ham during last hour of baking. Baste occasionally.

Or serve Ocean Spray just as it comes from the can . . . Jellied Cranberry Sauce cut in plump slices or fancy shapes . . . or Whole Cranberry Sauce, like mother used to make.

Left: Cranberry Ideas for your Easter Dinner were suggested as an accompaniment for either turkey or ham served on Easter Sunday. Ocean Spray said that the first commercial cranberry sauce was canned in 1912 by Marcus L. Urann, who owned cranberry bogs in Hanson, Massachusetts. Urann developed cranberry juice cocktail in 1933, and later created a syrup for mixed drinks. The famous canned cranberry sauce "log" that we know today would become available nationwide in 1941 by Ocean Spray, as either whole or jellied cranberry sauce.

Below: This straw-hatted little girl looks both wide-eyed and covetously at the slice of ham, yams and peas on her dinner plate at the dining room table before the family says prayers of thanks on Easter. With wide open eyes, not only she but the family looked forward to the traditional foods served at Easter, obviously with a glass of milk.

The Easter Surprise Cake was a chocolate cake made with perfect-blend dexo, an all-purpose creamy shortening, and the cake would surely brighten your Easter desserts. Dexo was available at the Great Atlantic & Pacific Tea Company that was founded in 1859 by George Gilman. The company opened a small chain of retail tea and coffee stores in New York City, and operated a national mail order business, which spread throughout the United States. In 1930, A&P was the world's largest retailer, and in 1936, it adopted the self-serve supermarket concept and opened 4,000 larger stores (while phasing out many of its smaller units) by 1950. What better way to enjoy the Easter Surprise Cake but with a cup of A&P Eight O'Clock Coffee.

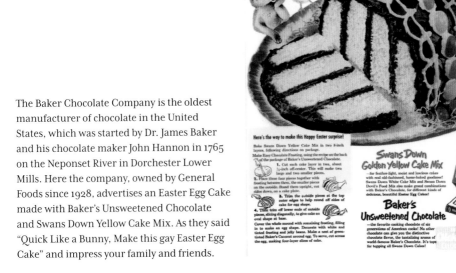

The Baker Chocolate Company is the oldest manufacturer of chocolate in the United States, which was started by Dr. James Baker and his chocolate maker John Hannon in 1765 on the Neponset River in Dorchester Lower Mills. Here the company, owned by General Foods since 1928, advertises an Easter Egg Cake made with Baker's Unsweetened Chocolate and Swans Down Yellow Cake Mix. As they said "Quick Like a Bunny, Make this gay Easter Egg Cake" and impress your family and friends.

Jell-O Puddings and Pie Fillings make for Red Letter Desserts and allowed one to "Let your Springtime Menus blossom out." The original gelatin dessert began in New York in 1897 when Pearle Bixby Wait trademarked the name "Jell-O" for a product made from strawberry, raspberry, orange, or lemon flavoring added to sugar and granulated gelatin, which had been patented in 1845 in its powdered form for the public. Here an Easter Sunday pie is made with Jell-O vanilla pudding and garnished with toasted coconut and colorful Jordan almonds. This delicious dessert was especially popular in the 1930s through the 1950s.

Duff's Ginger Bread mix was a quick and easy way to make old fashioned gingerbread goodies, and Dorothy Duff of Duff's Kitchen said "Your youngsters will love these cute Easter bunnies and eggs made with my Duff's Gingerbread Mix!" The P. Duff & Sons Company of Pittsburgh was founded in 1930 by John D. Duff, a molasses manufacturer; Duff experimented by drying out molasses with flour and allowing the mix to be rehydrated whenever it was needed, so this prepackaged mix allowed convenience and ease of baking. As *Bon Appetit* writer Michael Y. Park said: "Indeed, the company seems to have believed it had stumbled on the future of baking, and eventually brought the method it patented to bear on cakes, giving us what appear to be the first cake mixes."

Above left: Caffè Vittoria was established in 1929 by my cousins Salvatore and Magonella Giannelli Buccino as the first Italian cafe in Boston. Caffè Vittoria served a variety of Italian fancy pastries at Easter such as hollow chocolate Easter eggs wrapped in colorful cellophane and Colomba, a sweet Italian bread baked in the shape of a dove. Also Pizza Cheina, which at the end of Lent, people who had given up meat could enjoy this Easter pie, which was my grandmother Rose Giannelli Sammarco's favorite. However, the Torta di Pasqua, Casatiello Napoletano, and Pastiera Napoletana were special Easter desserts eagerly awaited annually.

Above right: S.S. Pierce & Company recalls neatly packaged foodstuffs that arrived by delivery truck, mail, or earlier by horse-drawn delivery wagon, in red boxes with the distinctive crest of the firm emblazoned on the wrappings and delivery boxes. Founded by Samuel Stillman Pierce in 1831, the store was run by four generations of the Pierce Family, and the company stood for gourmet foods, fine wines and liquors and exotic imports such as Singapore pineapple, sun-ripened canned peaches, brook trout from Iceland, and even rattlesnake meat. Here in 1941 an Easter basket of confections could be sent as a hostess gift to celebrate the holiday.

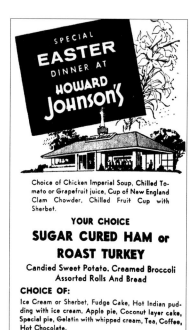

Howard Johnson created an orange-roofed empire of ice cream stands and restaurants that stretched from Maine to Florida and from the East Coast to the West Coast. Popularly known as the "Father of the Franchise Industry," Johnson and his numerous franchise restaurants delivered good food and ice cream at reasonable prices that brought appreciative customers back for more. The attractive white Colonial Revival restaurants, with eye-catching orange porcelain tile roofs, illuminated cupolas, and sea blue shutters, were described in *Reader's Digest* in 1949 as the epitome of "eating places that look like New England town meeting houses dressed up for Sunday." The Easter Sunday Special in 1960 offered either sugar-cured ham or roast turkey, with an appetizer, side dishes, dessert, and a beverage for $2.35!

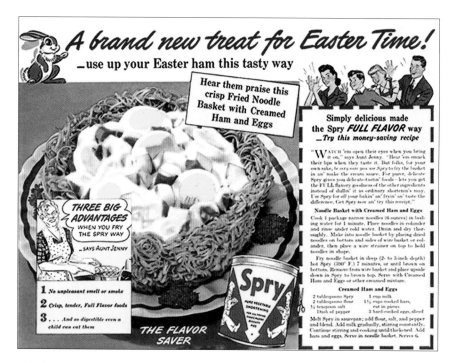

After having colored so many eggs for Easter morning, often many were left uneaten and what was one to do with them? Spry, "the Flavor Saver," offered a solution with a brand new treat for Easter Time! Seen here, this certainly was a novel way to use up both hard boiled eggs and Easter ham in a tasty way tossed in a cream sauce that is served in a crisp noodle basket.

10

EASTER BUNNIES

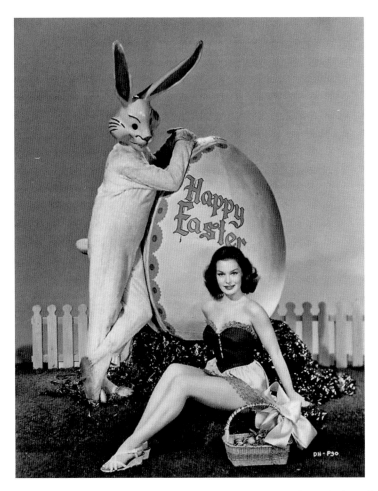

Dorothy Hart poses demurely with a wicker Easter basket filled with eggs before a huge Easter egg offering "Happy Easter" greetings to one and all as a larger than life Easter bunny stares at her. Hart was an American screen actress who won the Columbia Pictures "National Cinderella Cover Girl Contest of 1944." With a variety of screen acting performances she was cast as Jane when she appeared opposite Lex Barker as Tarzan in *Tarzan's Savage Fury* and she was to portray Howard Duff's fiancée in the 1948 film *The Naked City*.

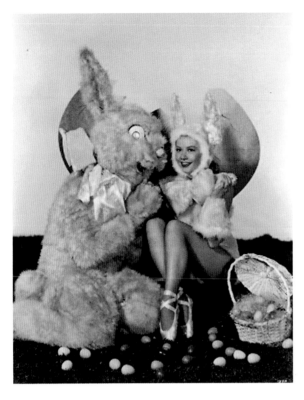

Vera-Ellen, whose real name was Vera-Ellen Westmeier Rohe, was an American dancer and actress. She is remembered for her solo dancing performances as well as her work with well-known dance partners Fred Astaire, Gene Kelly, and Donald O'Connor. She is best known for her starring roles in *On the Town* with Gene Kelly and *White Christmas* with Danny Kaye. Here she poses with an adoring Easter bunny in front of a large cracked Easter egg with a wicker Easter basket and eggs strewn in front on the grass.

Susan Hayward, whose real name was Edythe Marrenner, was an American actress and model whose acting had been recognized for her dramatic abilities with the first of five Academy Award for Best Actress nominations for her performance as an alcoholic in *Smash-Up, the Story of a Woman*. In 1958, she gave the performance of her lifetime in 1958 as real-life California killer Barbara Graham in *I Want to Live!*, who was convicted of murder and sentenced to death in the gas chamber. Hayward was absolutely riveting in her portrayal of the doomed woman. However, here she is a demure actress cuddling a stuffed Easter bunny with a sheaf of Madonna lilies in front.

Adle Jergens, whose real name was Adele Louisa Jurgenson, was named "Miss World's Fairest" at the 1939 New York World's Fair. In the early 1940s, she briefly worked as a Radio City Rockette and was named the Number One Showgirl in New York City. After such popular fame she went on to become an understudy to Gypsy Rose Lee in the Broadway show *Star and Garter* in 1942. Jergens landed a coveted movie contract with Columbia Pictures in 1944, which precluded that she became a blond. Here, seated on a bale of hay, Jergens is surrounded by white rabbits.

Ruth Roman, whose real name was Norma Roman, worked as a cigarette girl, a hat check girl and a model to make a living in the mid-1940s and was to be cast in several films such as *Stage Door Canteen*, *Ladies Courageous*, *Since You Went Away*, *Song of Nevada*, and *Storm Over Lisbon*. In recognition of Roman's rising status as a popular actress, Warner Brothers signed her to a long-term contract in 1949, casting her first as a supporting actress for Bette Davis in *Beyond the Forest* and then for Milton Berle and Virginia Mayo in *Always Leave Them Laughing*. Roman later had a successful career on television and in 1960 she was honored with a star on the Hollywood Walk of Fame. The eggs in her Easter basket seemed almost larger than life, and the white rabbits' fur match her outfit.

Deborah Paget, whose real name was Debralee Griffin, acted for Fox in the successful movie *Broken Arrow* with James Stewart, playing a young Native American maiden, Sonseeahray, who falls in love with Stewart's character. From 1950 to 1956, she took part in six original radio plays for Family Theater. She appeared in *Princess of the Nile*, co-starring Jeffrey Hunter, and though the film was not a notable success at the box office, the fan mail she received at 20th Century Fox was topped only by that for Marilyn Monroe. Paramount Pictures borrowed her from 20th Century Fox for the part of Lilia, the water girl, in Cecil B. DeMille's biblical epic *The Ten Commandments*, considered her most successful film. Here, dressed as a rabbit, she carries an Easter basket with a chick and eggs.

Gila Golan, born Gila Goldenberg, often appeared in the Israeli women's magazine *LaIsha*. Her fame and good looks landed her a spot in the 1960 national fashion competition, where she won first place and was crowned as Na'arat Israel—"Israel's Maiden of Beauty." Director Stanley Kramer started her film career with the role of Elsa Lutz in his 1965 film *Ship of Fools*. She continued to act in further films such as *Our Man Flint*, *I Dream of Jeannie*, *Three on a Couch*, *Catch as Catch Can*, and *The Valley of Gwangi*. Here Golan poses with large cracked Easter eggs and a stuffed rabbit and teddy bear.

Ann Miller, whose real name was Johnnie Lucille Collier, was a noted singer and dancer, who was famous for her speed in tap dancing, claiming she could tap 500 times per minute. An elegant and statuesque actress, she is best remembered for her work in the classic Hollywood cinema musicals of the 1940s and 1950s and she starred in the movie musical classics Vincent Minnelli's *Easter Parade*, Stanley Donen's *On the Town*, and George Sidney's *Kiss Me Kate*. Miller has a star on the Hollywood Walk of Fame. Here in a gingham pinafore apron dress she collects Easter eggs with a rabbit sitting in an open egg shell.

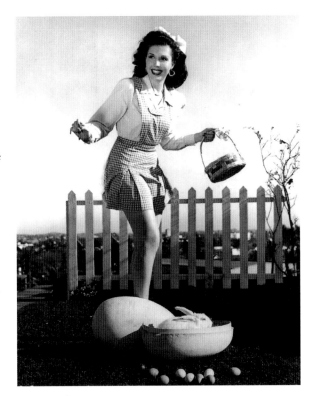

Mitzie Gaynor, whose real name was Francesca Marlene de Czanyi von Gerber, seemingly jumps out of a cracked Easter egg. As an actress she is probably best known for her role in *South Pacific*, the motion picture adaptation of the stage musical by Rogers and Hammerstein with her starring role as Ensign Nellie Forbush; for her performance, she was nominated for a Best Actress Golden Globe Award. Gaynor followed this with a comedy at MGM, *Happy Anniversary*, opposite David Niven, and the United Kingdom production *Surprise Package*, a musical comedy thriller directed by Stanley Donen, her co-stars were Yul Brenner and Noël Coward. Gaynor recorded two albums for the Verve Records label, one called *Mitzi* and the second called *Mitzi Gaynor Sings the Lyrics of Ira Gershwin*. In 2017, Mitzie Gaynor was inducted into the Great American Songbook Hall of Fame

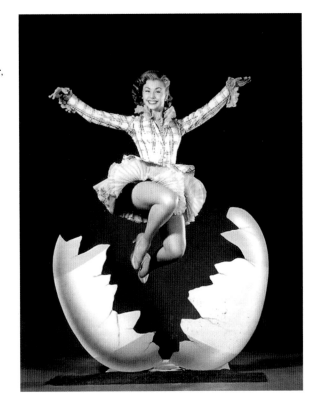

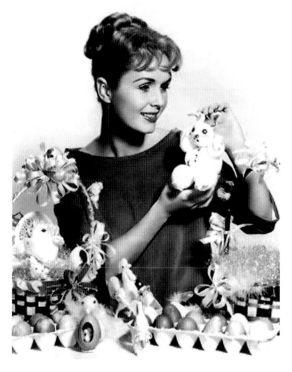

Debbie Reynolds, whose real name is Mary Frances Reynolds, was a popular All-American American actress, singer, and businesswoman. Among her many roles over seven decades, she would star in such wonderful films as *Singin' in the Rain*, *How the West Was Won*, and *The Unsinkable Molly Brown*. In 2015, Reynolds received the Screen Actors Guild Life Achievement Award, and in 2016, she received the Academy Awards Jean Hersholt Humanitarian Award. Here Reynolds has multi-colored Easter eggs in cardboard egg cartons, an Easter basket, and she holds a small stuffed rabbit.

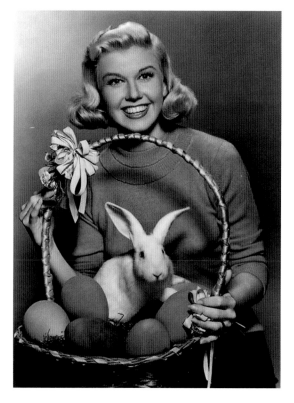

Doris Day, whose real name was Doris Mary Anne Kappelhoff, was the beloved actress and singer who began her remarkable career as a big band singer in 1939, achieving commercial success in 1945 with two No. 1 recordings "Sentimental Journey" and "My Dreams Are Getting Better All the Time" with Les Brown & His Band of Renown. She was quoted as saying in the book *Doris Day: Her Own Story* by Aaron E. Hotchner that "My public image is unshakably that of America's wholesome virgin, the girl next door, carefree and brimming with happiness. An image, I can assure you, more make-believe than any film part I ever played. But I am Miss Chastity Belt, and that's all there is to it." The actress holds an Easter basket with a live rabbit and larger than life eggs.

Elke Sommer (right), whose real name was Elke von Schletz, was a well-known sex symbol who had moved from Germany to Hollywood in the early 1960s. She was to become one of the most popular pin-up girls of the time, and went on to posed for several pictorials in *Playboy* magazine. Sommer became one of the top film actresses of the 1960s, and in 1964, she won a Golden Globe award as the Most Promising Newcomer Actress for *The Prize*, a film in which she co-starred with Paul Newman and Edward G. Robinson. Sommer also performed as a singer, and she recorded and releasing several albums. Sommer holds a stuffed Easter bunny with satin eggs hanging from a tree branch behind her.

Angie Dickinson (below), whose real name was Angeline Brown, was runner up at a local preliminary for the Miss America contest, and that got the attention of a casting agent who landed her a spot as one of six long-stemmed showgirls on *The Jimmy Durante Show*. In 1954, Dickinson made her television debut in an episode of *Death Valley Days*, which led to roles in such productions as *Matinee Theatre*, *City Detective*, *General Electric Theater*, *Northwest Passage*, *Gunsmoke*, and *The Virginian*. Dickinson's big-screen breakthrough role came in Howard Hawks' *Rio Bravo*, for which she received the Golden Globe Award for New Star of the Year. In the television show *Police Woman*, she played Sergeant Leann "Pepper" Anderson, an officer of the Los Angeles Police Department's Criminal Conspiracy Unit, who often worked undercover. The series became a hit, and ran for four seasons and Dickinson won a Golden Globe Award, and received Emmy Award nominations for three consecutive years. Here she holds the ears of a Bugs Bunny stuffed animal, both of them sporting an Easter bonnet.

Hugh Marston Heffner, on the right, was a *bon vivant* and man about town, and lived a lifestyle that he promoted in his magazine. His *Playboy* bunnies created a sensation in the 1960s with the age of sexual liberation and their scanty satin bikini-like outfits, bow ties on a white collar, satin rabbit ears, and a large puff bunny tail. Hefner was the founder of *Playboy* magazine, a publication with revealing photographs and articles that provoked charges of obscenity. The first issue of *Playboy* was published in 1953, featuring Marilyn Monroe in a nude calendar shoot, selling over 50,000 copies. In 1963, Hefner was arrested for promoting obscene literature after he published an issue of *Playboy* featuring nude shots of Jayne Mansfield in bed with a man. Always courting publicity, Hefner created an aura of excitement and titillating entertainment in mid-twentieth-century America.

The *Playboy* Club at Park Square in Boston was established in 1960 as part of a "private key" chain of nightclubs and resorts owned and operated by *Playboy* Enterprises. *Playboy* Club membership became an instant status symbol at that time and each member paid dues to have their own rabbit-headed metal *Playboy* key that was shown to the door bunny to gain admission to the club. The club featured a living room, a playmate bar, a dining room, and a club room on various floors. Members and their guests were served food and drinks by *Playboy* bunnies, some of whom were featured in *Playboy* magazine. Unfortunately, in 1991, the club chain became defunct.